Murillo's Allegories
of
Salvation
and
Triumph

Murillo's Allegories of Salvation and Triumph

The Parable of the Prodigal Son
and *The Life of Jacob*

Mindy Nancarrow Taggard

UNIVERSITY OF MISSOURI PRESS
Columbia and London

Library of Congress Cataloging-in-Publication Data

Taggard, Mindy Nancarrow.
 Murillo's allegories of salvation and triumph : the Parable of the
prodigal son and the Life of Jacob / Mindy Nancarrow Taggard.
 p. cm.
 Includes bibliographical references and index.
 ISBN 0-8262-0872-X
 1. Murillo, Bartolomé Esteban, 1617-1682. Parable of the prodigal
son. 2. Murillo, Bartolomé Esteban, 1617-1682. Life of Jacob.
3. Murillo, Bartolomé Esteban, 1617-1682—Criticism and
interpretation. 4. Allegories. 5. Counter-Reformation in art.
I. Title.
ND813.M9P378 1992
759.6—dc20 92-28879
 CIP

∞™ This paper meets the requirements of the
American National Standard for Permanence of Paper
for Printed Library Materials, Z39.48, 1984.

This work is brought to publication with the assistance of
The Program for Cultural Cooperation Between Spain's Ministry
of Culture and United States Universities.

Designer: Kristie Lee
Typesetter: Connell-Zeko Type & Graphics
Printer and Binder: Thomson-Shore, Inc.
Typeface: Galliard

for José Antonio

Contents

Acknowledgments

This book originated in a doctoral dissertation presented to the Kress Foundation Department of Art History of the University of Kansas in 1985. The helpful comments of the dissertation readers prompted me to extend my research prior to rewriting the dissertation for publication. I returned to Spain in the summer of 1986 to investigate further Murillo's literary sources for the paintings, and the life and family history of the Marquis of Villamanrique, the probable patron for *The Life of Jacob*. Between 1987 and 1990 I integrated new information uncovered in Madrid's archives with my previous research and drafted the present text, whose organization and content differ substantially from that of the dissertation. While I am satisfied that the present text illuminates the complexities of Murillo's paintings much better than did the dissertation, I am fully aware that the ideas and speculations presented in this book will not convince all readers. I only hope that the pages that follow will prove of interest to some and help to foster a much-needed discussion of the complex cultural underpinnings of Murillo's art.

Funding for the research and preparation of this manuscript has come from three sources. The investigation that produced the dissertation was supported by a Fulbright-Hays Dissertation Research Grant to Spain, which I enjoyed between 1982 and 1983. The research completed in Madrid in the summer of 1986 was funded by the Dean of Arts and Science's Research Incentive Grant Program of Oklahoma State University (Stillwater). In 1987 the same program supported the writing and editing of a first draft of the present text. Part of the cost of purchasing photographs to illustrate this book was absorbed by the College of Arts and Sciences and the Department of Art of the University of Alabama (Tuscaloosa).

A number of people and institutions have been instrumental in bringing this book to publication. For her very generous help and expert guidance throughout the researching and writing of the dissertation, I feel a special sense of gratitude to my adviser, Linda Stone-Ferrier. The model of professionalism that she provided me continues to serve me to the present day. For their many helpful suggestions, some of which I pursued only for the book, I also wish to thank two of the readers of the dissertation, Marilyn Stokstad and Elizabeth Broun. I am grateful to the late Diego Angulo Iñiguez, of Spain, whose scholarly responses to my questions clarified for me many of the issues discussed in this book. For their helpful assistance throughout the research process, I would like to thank the staff of Madrid's Biblioteca Nacional, where the bulk of the investigation was undertaken, and the staffs of the Real Academia de la Historia, Archivo de Valencia de don Juan, and Archivo Histórico de Protocolos, all of which are located in Madrid. In its final stages the manuscript profited from the thoughtful comments of two anonymous readers for the University of Missouri Press. I am especially grateful to one of these readers, who kindly volunteered to read a second, revised version of the manuscript. Editorial assistance for the manuscript was provided by Lucy Langworthy, Kelly Turner, and the editors at the University of Missouri Press.

For their love, moral support, and financial assistance, extended to me over these many years, I am absolutely and forever indebted to my parents, George and Hilda Nancarrow, of Dallas, Texas. Finally, I would like to thank José Antonio Cano for his encouragement of my work and unflagging interest in this project. His valuable input has clarified for me many of the fine points of Spanish language and law, and his knowledgeable discussions of Spanish literature, which I have enjoyed for many years, have enriched this manuscript in countless ways.

Murillo's Allegories of Salvation and Triumph

Introduction

artolomé Esteban Murillo (1617/18–1682) is considered to be Spain's finest painter of the late Baroque period. This book develops the allegorical meanings of two exquisite narrative series of paintings by Murillo, *The Parable of the Prodigal Son* (figs. 1–6) and *The Life of Jacob* (figs. 29–32).[1] These two sophisticated series were conceived by Murillo during his busiest decade (1660–1670), when he was also occupied with paintings for Seville's Church of Santa María la Blanca, Capuchin Monastery and the Church of the Brotherhood of Charity.[2] Murillo's painted narratives are unusual in that they illustrate biblical stories in a serial format. His *The Parable of the Prodigal Son,* six colorful paintings elaborated for an unidentified patron, represents Christ's famous parable recorded in the Gospel of Luke. His *The Life of Jacob,* five very large canvases most likely commissioned by Seville's Marquis of Villamanrique, presents the Old Testament patriarch found in Genesis. The extended allegories that structure Murillo's pictorial narratives are substantiated through contemporary Spanish theology, drama, and moral philosophy. How these documented allegories determined the final appearance of Murillo's *The Parable of the Prodigal Son* and *The Life of Jacob,* while also responding to Spain's cataclysmic political, social, and economic decline in the late seventeenth century, is the subject of the present study.

Serial illustrations of Old Testament stories and parables are not common in Spanish Baroque art. Peninsular painters usually restricted their biblical subjects to the confines of a single canvas, two familiar examples being Diego de Velázquez's (1599–1660) *Joseph's Bloodied Coat Presented to Jacob* (El Escorial) and Jusepe de Ribera's (1588–1656) *The Dream of Jacob* (fig. 36). Less common was the practice of creating a

narrative series of paintings based upon a Bible story; however, there
were times when this practice was employed, and the six paintings
that make up Antonio del Castillo's (1616–1668) *The Life of Joseph* (Mu-
seo del Prado, Madrid) are one example. Serial biblical narratives also
appear in Spanish inventories where they are recognized by their des-
ignation of *historias*.³ For example, the Sevillian gentleman Domingo
de Urbizu (d. 1701) owned six paintings of unspecified histories, and
Cristóbal de Pedrosa y Luque, whose possessions were inventoried in
Seville in the same year, owned four landscapes (*países*) with scenes of
the life of David.⁴ Furthermore, the term *historieja*, a diminutive of
historia, is used in documents to designate narrative paintings that are
small in scale and/or unambitious in composition.

The designations *historia* or *historieja* in the inventories do not nec-
essarily, however, imply a continuous narrative. Often the paintings
that compose a narrative set are coordinated by a unifying allegory or
by broad thematic analogies; for example, all scenes included in a nar-
rative series might represent historic meetings or journeys. Castillo's
The Life of Joseph depicts Christ's Passion allegorically, and two paint-
ings inventoried in 1715 among the possessions of Murillo's son Gaspar
(*Jacob's Dream of the Ladder* and *The Dream of Joseph*) are united by the
common theme of the dream.⁵ Additionally, the small-scale *historiejas*
could be synchronized by compositional similarities. According to
the famous biographer of Spanish artists, Antonio Palomino (1653–
1726), the painter Francisco Antolinez (d. 1700) grouped his *historiejas*
of scriptural subjects according to their landscape backgrounds and
sold them on the open market in Madrid.⁶

Murillo's *The Parable of the Prodigal Son* is structured as a continu-
ous narrative with a unifying allegory. This series's six medium-sized
paintings are preserved together in the National Gallery of Ireland
(Dublin), and four small, preliminary oil studies are found in Ma-
drid's Museo del Prado (figs. 20, 26).⁷ Murillo's lively series, *The Par-
able of the Prodigal Son*, illustrates the first half of Christ's parable in
Luke, outlining the events from the prodigal's taking of his inheri-
tance to his return to his father's home. In order, the six represented
scenes are *The Prodigal Son Receiving His Portion, The Departure of the
Prodigal Son, The Prodigal Son Feasting, The Prodigal Son Driven Out,*

The Repentance of the Prodigal Son, and *The Return of the Prodigal Son.* Sketched out in the oil studies are the cycle's first, third, fifth, and sixth scenes. The allegorical structure of Murillo's painted narrative is given by the parable. Like the gospel's moral, Murillo's six canvases offer the viewer a visual lesson in sin, repentance, and forgiveness.

Murillo's pictorial narrative *The Life of Jacob* is, however, more difficult to interpret. While this cycle's massive scale and exceptional quality attest to the deliberate selection of the five scenes, *The Blessing of Jacob* and *The Dream of the Ladder* (both Hermitage, St. Petersburg), *The Meeting of Jacob and Rachel* (whereabouts unknown), *The Laying of the Peeled Rods* (Meadows Museum, Dallas), and *Laban Searching for His Stolen Household Gods* (Cleveland Museum of Art), the series's seeming lack of a conclusion has thwarted scholarly interpretation.[8] The abrupt finale of *The Life of Jacob,* in which Laban accuses Jacob of stealing his pagan gods, seems to leave unresolved the sibling rivalry initiated by the usurping of the blessing depicted in the opening scene. However, the presence of a "hidden" unifying conceit explains Murillo's unusual choices of scenes. This study will show that Murillo's five episodes were selected in accordance with the familiar Catholic conceit of "the triumph of the faith," a favorite among Spanish Baroque artists. Within this allegory, the patriarch serves as a foil for Christ, his consort represents the Church, and his father-in-law embodies heresy.

This study documents the spiritual significance of Murillo's two series through related religious and secular literature. The lives of the prodigal and the patriarch were interpreted symbolically as early as the fourth century by Christian theologians whose exegeses were fundamental to Spain's sixteenth- and seventeenth-century apologists. Writings by peninsular theologians clarify the peculiarly Spanish, Roman Catholic, and Tridentine nature of Murillo's biblical interpretations. The Scriptures were also invoked by Spanish dramatists of the Golden Age, whose scripts constitute an especially fruitful source for the interpretation of Murillo's painted narratives which, like the plays, follow a scene-by-scene format. Dialogue and stage directions in the scripts help explain the structure of Murillo's series, as well as many of his choices of costumes and settings in the individual paintings.

The allegories herein developed for Murillo's two series are not un-expected in Spanish art of the late seventeenth century. The tale of a privileged youth who suffers extreme deprivation for displeasing his parent but is absolved through repentance conforms to the mood of self-recrimination that swept the peninsula in the latter half of the seventeenth century. The Spanish sense of culpability, fostered by the decline of the empire, escalated after 1665 when Philip IV's feeble-minded infant son, Charles II, assumed the throne vacated by his deceased father. It was particularly exaggerated in Seville, whose privileged status as the sole port of entry for the lucrative New World trade was fast ending. As Seville's channel to the Atlantic became impassable with silt, the maritime traffic, which had been the source of its prosperity, shifted to neighboring Cadiz. Seville, Spain's richest and most cosmopolitan city at the start of the seventeenth century, sank into the twilight of obscurity before the dawn of the eighteenth century.

The metaphorical triumph expressed in *The Life of Jacob* is directly linked to the progressive decline of the empire under its Hapsburg monarchy. The Spanish subjects who financed Philip IV's costly military ventures maintained their morale through faith in the monarchy's inevitable vindication. Their vision dimmed with Spain's mounting military defeats and territorial losses: the northern Netherlands in 1648; Jamaica, taken by the English in 1655; Artois and Roussillon, ceded to the French in 1659; and Portugal in 1668. Only in paintings and plays did the Spanish dream materialize. The increasing popularity of pictorial triumphs with Spanish patrons after mid-century is attested to by countless paintings, including Francisco de Herrera the Younger's *The Triumph of St. Hermengild* (1654; Museo del Prado, Madrid) and Claudio Coello's *The Triumph of St. Augustine* (1664; Museo del Prado, Madrid) and *St. Catherine of Alexandria Dominating the Emperor Maxentius* (fig. 35).[9] Dramatic scripts, particularly the allegorical plays of Pedro Calderón de la Barca (1600–1681), Philip IV's celebrated court dramatist, also confirm the interest in the triumphal theme.[10] The taste for allegorical triumphs increased in proportion to the monarchy's decline, and it expired, along with Spain's shattered dreams, in the last quarter of the seventeenth century.

The Parable of the Prodigal Son and *The Life of Jacob,* two exquisite

narrative series of paintings conceived by the Sevillian Bartolomé Murillo in the watershed decade of 1660–1670, serve as case studies to better understand how such cycles of paintings were understood by their seventeenth-century Spanish patrons. Part 1 of this study explores the allegorical significance of Murillo's *The Parable of the Prodigal Son*, and Part 2 investigates the spiritual subtext of his five splendid canvases that make up *The Life of Jacob*.

Part I

*The Parable of the
Prodigal Son*

1

Precedents, Patron, and Allegory

urillo's series *The Parable of the Prodigal Son* (figs. 1–6) constitutes a unique Spanish pictorial narrative. Murillo's delightful interpretation of Christ's moral as a contemporary, seventeenth-century Spanish tale has precedents in Golden Age literature, while his unifying allegory of the theological history of mankind—creation, fall, and redemption—compares to the dramatizations of Spanish playwrights. However, Christ's famous parable, which inspired numerous illustrations elsewhere in Europe, was virtually ignored by Spanish artists, who only occasionally represented either of the episodes illustrated by Murillo's two final paintings: the prodigal's repentance and his return. An explanation for the dearth of Spanish precedents for Murillo's third scene, *The Prodigal Son Feasting,* also accounts for the absence of Spanish serial illustrations of the parable.

The indifference Spanish painters demonstrated toward the entirety of Christ's parable is disconcerting, given the tremendous popularity that the story enjoyed with artists elsewhere on the Continent. Sixteenth-century northern European illustrations of the tale include the print series of Flemings Philip Galle and Jacob Matham, Dutchman Maerten van Heemskerck, and German Hans Sebald Beham, to name but a few. Northern European interest was especially keen in a single episode of the narrative, the prodigal's "wasting of his substance among the harlots" (Luke 15:13, 30). Luke's titillating verses,

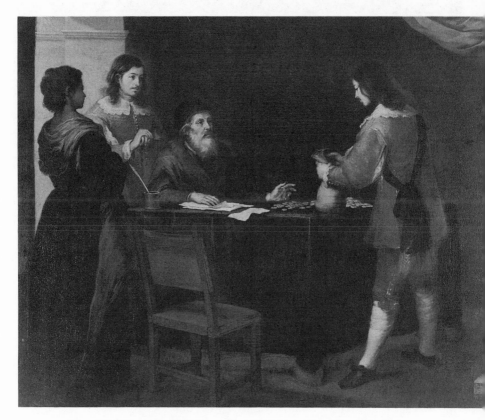

1. Bartolomé Esteban Murillo, *The Prodigal Son Receiving His Portion*, ca. 1660–1670. National Gallery of Ireland (Beit Collection).

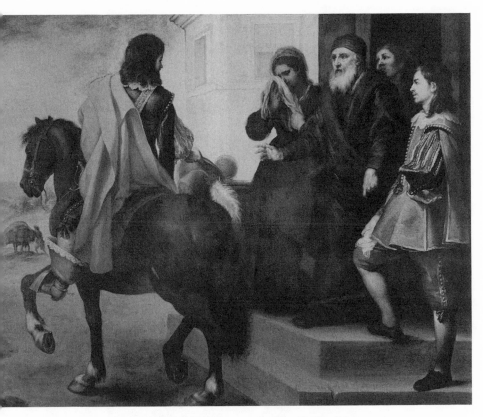

2. Bartolomé Esteban Murillo, *The Departure of the Prodigal Son,*
ca. 1660–1670. National Gallery of Ireland (Beit Collection).

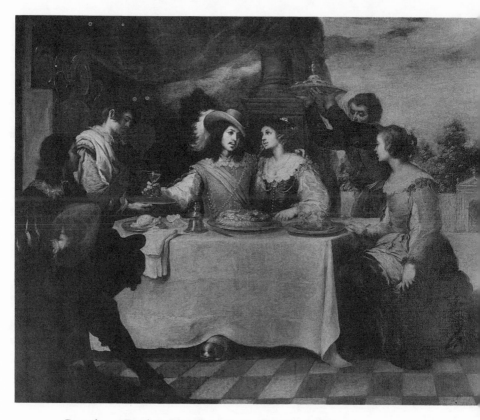

3. Bartolomé Esteban Murillo, *The Prodigal Son Feasting,* ca. 1660–1670.
National Gallery of Ireland (Beit Collection).

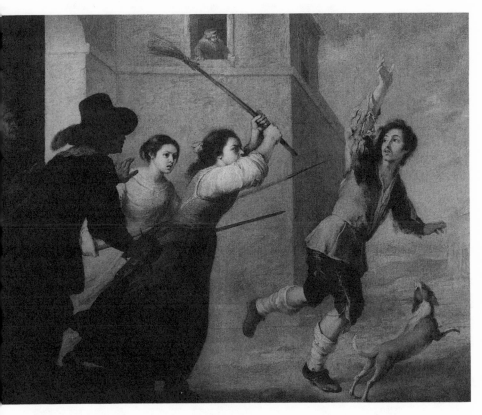

4. Bartolomé Esteban Murillo, *The Prodigal Son Driven Out,* ca. 1660–1670.
National Gallery of Ireland (Beit Collection).

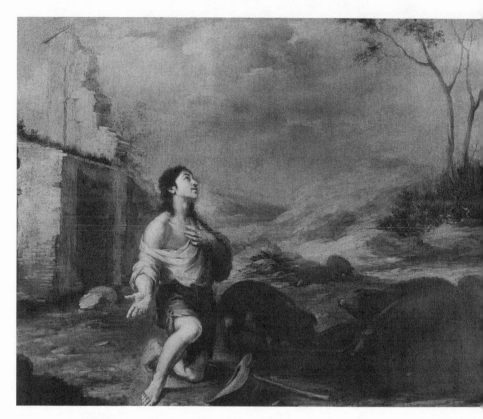

5. Bartolomé Esteban Murillo, *The Repentance of the Prodigal Son*, ca. 1660–1670. National Gallery of Ireland (Beit Collection).

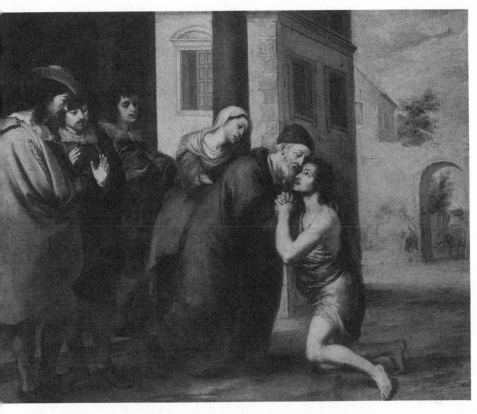

6. Bartolomé Esteban Murillo, *The Return of the Prodigal Son*,
ca. 1660–1670. National Gallery of Ireland (Beit Collection).

which Spanish artists avoided, probably because they required the presence of prostitutes, were so popular in Holland and Flanders that an artist often enlarged the erotic episode in the center of a composition and represented the remainder of the story in tiny background vignettes. Two examples of this popular format are a 1536 painting by Dutchman Jan van Hemessen (Musées Royaux des Beaux-Arts, Brussels) and a circa 1630 canvas by Fleming Frans Francken the Younger (fig. 13). In Spain the prodigal's debauchery was difficult to represent because it violated the dictums of the mid-sixteenth-century Council of Trent. At that meeting in 1563, Catholic churchmen clearly outlined the salutary benefits of viewing holy images and the pernicious effects of seeing lewd, or unchaste, scenes.[1] The Sevillian painter Francisco Pacheco (1564–1644) reiterated the synod's warning in his popular artist's manual, *El arte de la pintura* (The art of painting, 1649). Pacheco alerted his fellow artists to the "grave danger Christian painters cause to their souls and those of other men by painting lascivious figures, or stories, which incite sensuality in the same measure that saintly images provoke virtue and devotion."[2] Antonio Palomino included a similar warning in his early eighteenth-century art treatise, *El museo pictórico y escala óptica* (The pictorial museum and an optical scale). Observing that, in Spain, honor was more scrupulous than in the rest of Europe, this theorist from Cordoba admonished, "Regarding circumspection in invention, be it history, or be it a single figure, it is imperative to give great attention to the decency, modesty and decorum of the figures; although among Catholics it seems reprehensible that this point should require reflection." While we know that the watchful discretion that Palomino urged on the artists of Spain was enforced by the church through its censors of the visual arts, the extent of this control remains unclear. Palomino declared that the creator of a lascivious painting was subject to excommunication, fines, and exile, but evidence of imposition of the penalties has not been found.[3] However, the virtual absence from Spanish art of sexually provocative or even suggestive images suggests that some degree of control—psychological or societal, if not legal—was exerted over the country's artists.[4]

Murillo's unusual production of a painted narrative that includes a

scene of dissipation is not explained by either his exceptional creative urges or his apparent artistic freedom. Instead, the answer is more logically found in the identity and demands of his patron, who was most likely a foreigner exempt from most Spanish restrictions. Alien residents of Seville were not constrained by the same laws as were their Spanish neighbors. For example, a treaty of 1604 granted English Protestants immunity from the Catholic Inquisition.[5] Murillo's popularity with the foreign citizens of Seville is evident in the prosperous clients he attracted, including the Dutch merchant Joshua van Belle and the Flemish trader Nicolás Omazur. The 1690 inventory of Omazur's extensive art collection includes some forty attributions to Murillo.[6]

Although the identity of the patron of *The Parable of the Prodigal Son* has yet to be documented, he may be the elusive Englishman cited by Santiago Montoto de Sedas in his indispensable biography of Murillo (1923). Montoto reported that a colleague of his uncovered a contract dated *about* 1671 in Seville's notarial archive. Montoto asserts that in this lost document Murillo agrees to create six paintings for don Francisco de la Puente and a Duarte. Distinguished as a *licenciado,* or graduate of an institution of higher learning, Duarte is further identified in a 1671 rental contract as an Englishman. In this second document, which Montoto did publish, Murillo agrees to lease a house for a period of eight months to "Duarte Pedro, inglés," whose name is probably a corruption of the English Edward Peter.[7]

The short duration of the rental contract, along with the nationality of the leaseholder, may explain the unusual listing of two patrons on the first document. Local laws in a busy port city such as Seville, which enjoyed a large and transient foreign population, probably required that transactions between Spaniards and aliens be guaranteed by a third party who vouched for the foreigner in question.[8] Francisco de la Puente, the other patron included in the contract, may have served as a guarantor for Duarte, most likely the actual patron of Murillo's six narrative paintings.

Still unclear, however, is whether the series mentioned by Montoto is *The Parable of the Prodigal Son.* The disappearance of the contract sometime before Montoto published his information in 1923 obscures

the question.⁹ However, the number of paintings, as well as the contract's date, which Montoto recalled as 1671, makes the identification likely.

While the patron's alien status may have expanded Murillo's latitude of invention, it did not affect his interpretation of the parable as a contemporary, seventeenth-century Spanish tale. The gospel story of a well-to-do profligate who squanders his inheritance was apropos to Murillo's society. Seventeenth-century Spaniards viewed the earning of money through labor or commerce as ungentlemanly and consequently dissuaded their sons from most types of gainful employment. This standard thus excluded most careers except the church and the military, and the established practice of entailing, which allowed the eldest son to preserve the family wealth, fostered a host of idle playboys in Spain.¹⁰ The consequences for Seville, where the problem was aggravated by the greater number of fortunes amassed through New World trade and entailed for inheritance, were dire. The dilemma was addressed as early as 1603 by the Sevillian cleric Francisco de Luque Faxardo in his treatise *Fiel desengaño contra la ociosidad, y los juegos* (Faithful revelation against idleness, and gambling). Luque Faxardo's book is written as a dialogue between two young Sevillian nobles and exposes one of the pitfalls of idleness: gambling. Related to this theme is Tirso de Molina's (pseudonym of Fray Gabriel Téllez, 1571–1648) immortal play *El burlador de Sevilla y convidado de piedra* (The beguiler from Seville and the stone guest), circa 1616. Don Juan was the mythical libertine of Tirso's play; in the twentieth century, the name has become synonymous with womanizer. The popular literary character *don Juan* has been compared by some to a historical figure, Miguel Mañara Vicentelo de Leca (1627–1679), *hermano mayor*, or leader, of Seville's Brotherhood of Charity. One of Murillo's more enlightened patrons, Mañara claimed to have undergone a prodigal youth, which he subsequently repented, and he was reformed into a servant of God, much like the sinner in Luke's Gospel.¹¹

The applicability of the gospel moral to the seventeenth-century society of Murillo explains the distinctive Spanish flavor of the cycle *The Parable of the Prodigal Son*. Typically Spanish details in the first painting (fig. 1) include the two chairs with slightly raked backs and

velvet or leather upholsteries attached to the frames by large nails. Examples of the popular *sillón frailero,* or monk's chair, their traditional design dates to the sixteenth century, during the reign of Philip II.[12] The bell-shaped salt cellar represented on the banqueting table in Murillo's third painting, *The Prodigal Son Feasting* (fig. 3), as well as the flamboyant ewer displayed on the sideboard at the left, correspond to seventeenth-century Sevillian metalwork designs. The tripartite condiment dispenser resembles pattern thirteen in the Sevillian silversmith's manual, *Libro primero de dibujos para examenes de los plateros sevillanos* (First book of drawings for examinations of Sevillian silversmiths), and the ewer, which relates to a type popular in Seville early in the seventeenth century, is similar to the manual's diagram nineteen.[13]

The colorful costumes represented in *The Parable of the Prodigal Son* also correspond to late seventeenth-century peninsular fashion. The elegant dress of the prodigal and his brother in the first painting, consisting of unconfined, thigh-length jackets, (*casacas*), knee breeches, and wide, unstarched collars, conforms to costumes in other, contemporary Spanish paintings, including *The Dream of the Knight,* attributed to Antonio de Pereda (fig. 23), and Murillo's *Portrait of don Antonio de Hurtado de Salcedo* (ca. 1664; private collection, Spain).[14] While the sumptuous attire the women wear in the third painting also represents late seventeenth-century fashion, like that adorning the bride in Murillo's *The Marriage Feast at Cana* (fig. 15), their revealing, low-cut bodices do not. This immodesty, which is anomalous to Spanish Baroque art, emphatically identifies the women as prostitutes.

Prostitution was tolerated in Spain in the sixteenth century. In Seville, houses dedicated to the practice were restricted to the far edge of town on a boggy expanse known as *El Compás* and were often leased by legitimate institutions such as hospitals and convents. When Philip IV criminalized prostitution in 1623, Seville's prostitutes either went underground or turned to the protection of any of Seville's three hundred gaming houses.[15] An edict issued sixteen years after the ban was another attempt to regulate prostitution, and in 1640, when Spain's entire body of legislation was republished, it was deemed necessary to retain regulations regarding the dress of prostitutes. The unadorned

attire of the courtesans in Murillo's fourth painting (fig. 4) conforms to the law enacted during the reign of Philip II and reissued in 1640 that prohibited prostitutes from wearing gold, silk, or pearls beyond the doorways of their establishments.[16]

Even so, Murillo's two romanticized depictions of prostitution, *The Prodigal Son Feasting* and *The Prodigal Son Driven Out* (figs. 3, 4), are modeled more closely after the fanciful tales of the Golden Age writers. The prodigal's likeness to the *pícaro,* the roguish young hero of the popular Spanish literary genre of picaresque, was first observed in the nineteenth century by the discerning English traveler Richard Ford (1796–1858). Ford, who had probably read Mateo Alemán's classic picaresque novel *Guzmán de Alfarache* (1599), recorded in his diary, following a visit to Madrid's Prado Museum, that the paintings (he must have seen the oil sketches that have been in that collection since 1819 rather than the finished works) were "excellent, but treated both as to costume and conception rather according to a picaresque Spanish novel than Holy Writ."[17]

But the prodigal's pampered upbringing, which distinguishes him from the low-born *pícaro,* recalls another, equally well-known literary figure: the *galán,* or gallant. The *galán,* idle, elegant young hero of scores of seventeenth-century Spanish plays, is the protagonist of all those based upon the biblical parable. In the guise of the *galán,* the gospel youth appears upon the stage as early as the mid-sixteenth century in the anonymous religious play *Aucto del hijo pródigo* (*Auto* of the prodigal son) and in Luis de Miranda's *Comedia pródiga* (Prodigal comedy, 1554).[18] Spain's most prolific seventeenth-century dramatist, Félix Lope de Vega Carpio (1562–1635), interpreted the story twice: as a one-act morality play, *El hijo pródigo* (The prodigal son), published in 1604, and as a comedy, *La prueba de los amigos* (The test of friendship), completed in the same year.[19] During the seventeenth century, the tale was also adapted by the Toledan cleric José de Valdivielso (ca. 1560–1638) in an *auto sacramental* (eucharistic play), *El hijo pródigo,* published in 1622, and by Tirso de Molina.[20] In about 1620, Tirso synthesized the prodigal's story with the parable of the rich man and poor Lazarus in his ingenious script *Tanto es lo de más como lo de menos* (Too much is as bad as too little).[21]

Although each Spanish playwright develops Luke's verses differently—Miranda enlisting the prodigal for a continental war, Lope condemning him to incarceration—shared by all is one interpretation of the sinner. Invariably, he is characterized as a young and painfully inexperienced *gálan*, whose disastrous end is the calamitous result of his acute naïveté rather than the product of any inherent evil. The dramatization of his corruption by the unscrupulous courtesans offers a warning to all young men of the dangers that lurk in the world. As Miranda states upon the title page of his *Comedia pródiga*, "[My play] contains many necessary sentences and warnings for young men setting out into the world: demonstrating to them the deceits and mockeries that are disguised in false friends, bad women, and traitorous servants."[22]

The lesson in life's pitfalls that leads to redemption in Murillo's narrative conforms to the religious plays of Lope and Valdivielso. Lope's *El hijo pródigo* and Valdivielso's *auto sacramental* describe the prodigal's fall allegorically. The tarnishing of his soul by his sinful abandonment of his heavenly Father provides a preamble for lengthy expositions on the redemption available to the sinner through the Catholic sacrament of penance. In Valdivielso's script, the wayward youth is dogged by the allegorical figure of Inspiration, who employs apocalyptic demonstrations of the triumph of death and the fires of hell to elicit the youth's repentance. Enacted upon the stage via the *carros,* or small, rollaway sets, these two tangible arguments are followed by a third *carro* that illustrates the joys of divine mercy with the figure of a child tied to a cross supported by four angels.[23]

Murillo proclaims the Christian message of redemption in *The Parable of the Prodigal Son*. Represented in the first canvas, *The Prodigal Son Receiving His Portion,* is the creation of the soul of man, personified by the prodigal, who, in the second composition, foolishly abandons his heavenly Father. The Fall of Man is detailed allegorically in the third painting as the corruption of the prodigal's five God-given senses. The series's fourth scene, *The Prodigal Son Driven Out,* separates the sinner from his vices to ready him for his subsequent redemption. The last two canvases conclude the painted narrative by representing the proper execution of the important Catholic sacrament of

penance. Murillo's fifth painting illustrates the proper method of confession, and his sixth and final scene, *The Return of the Prodigal Son,* declares the joyous boon of the holy sacrament in the absolution granted the sinner by his merciful Father. Thus Murillo's narrative paintings are a visual reminder of the moral in Christ's parable.

2

Creation: Wayward Souls and Positive Counterexamples

The first two paintings in Murillo's remarkable series initiate the theological history of mankind. According to the theologian St. Augustine (354–430), the prodigal son receiving his portion and the departure of the prodigal son symbolically represent the two types of souls created by God. The painter illustrates these inverse roots of the human race with the prodigal symbolizing the wayward souls and his elder brother representing the virtuous ones. Following Augustine's interpretation, Murillo manipulates the father's costume and physiognomy to characterize him as God the Father. The silent, anonymous women present as observers in Murillo's first two canvases supply pious counterexamples to the sensual harlots of the third and fourth compositions. Together they personify the choice that the prodigal must make between virtue and vice. *The Departure of the Prodigal Son* illustrates the wayward soul's foolish decision to abandon the heavenly home.[1]

In *The Prodigal Son Receiving His Portion* (fig. 1), Murillo introduces the viewer to two souls who will elect different paths. The painting illustrates Luke 15:11–12: "A certain man had two sons: And the younger of them said to his father, Father give me the portion of goods that falleth to me. And he divided unto them his living." In Murillo's first canvas, the younger, prodigal offspring eagerly tightens the neck of a bag whose contents are declared by the gold and silver coins strewn about the counter. Witnessing his greed are his disconsolate father,

whose hand is raised in a vain attempt to stay his disobedient son, his self-effacing older brother, who poses obediently behind the parent's chair, and a silent female observer, who stands in the shadows in the left side of the painting. The elder brother is a duplicate of the prodigal except that he displays a kindly facial expression. The siblings have similar aquiline noses, long, dark hair and moustaches, and they wear identical gold-colored suits accented by wide, flat collars.

Murillo's mirror-image conception of the brothers differs in one crucial respect from its apparent source, a woodcut print by the German artist Marc Anton Hannas (1610–1676; fig. 7). In the print, the elder brother's downcast eyes and smirking lip declare smug self-satisfaction; however, the figure in the painting appears sincere and unassuming. His honest soul is revealed by the concerned look upon his face, and his dutiful obedience to his father is underscored by his careful placement behind the parent's chair with his hands posed serenely atop its finials.

The sterling character of the elder brother in the painting also differs from the personality described in the Bible. Luke 15, which confirms the brother's existence at the start of the story, characterizes him only after his sibling's return. He envies the prodigal the warm welcome he receives from their father, and that provides a lesson in the error of self-righteousness: verses 25–32 describe an ill-tempered, begrudging, and wholly unlikable individual.

The unusual model role of the elder brother in Murillo's series finds its source in the writings of St. Augustine and the church's doctrine of free will. Augustine elaborated the spiritual significance of the parable. He explains that "This man having two sons is understood to be God having two nations, as if they were two roots of the human race; and the one composed of those who have remained in the worship of God, the other, of those who have ever deserted God."[2] Augustine's interpretation implies that humanity's dual roots decide the spiritual choices of their free will. The parameters of individual free will were hotly debated in seventeenth-century Spain by the religious orders. But they generally agreed that all souls are created equal by a God, who, in His infinite wisdom, predestined some to be chosen and some to be rejected. Although an individual could not know his ultimate fate during his lifetime, using his free will, he was to act as if

DER VERLOHRNE SOHN THUT. VND EHREN BIS INS GRAB.
VON FURWIZ SO GETRIBEN. IHM SEIN VERMEINTES TEIL,
ER SEINEN VATTER ZWANG, UND ALLER GUTER HELFT
DEN ER DOCH SOLLEN LIEBEN. ZU GEBEN IHN IN EILL.

7. Marc Anton Hannas, *The Prodigal Son Receiving His Portion,* mid-seventeenth century. Graphische Sammlung, Albertina.

he were among the chosen. Then, with the grace of God, he might truly be elected.[3]

Murillo represents the prodigal's misuse of his free will in *The Prodigal Son Receiving His Portion.* His original equality with his virtuous sibling, expressed in the painting by the brothers' matching outfits and identical facial features, is negated by the prodigal's diagonally tied black sash, as well as by his greedy expression. The prodigal's dark

accessory is his stigma. It alerts the viewer that the prodigal alone has elected poorly by choosing to abandon his heavenly Father.

The physical appearance and costume of the prodigal's father in Murillo's painting makes it patently clear whom the youth is denying in exerting his will. The parent's large, powerful figure and long white beard correspond to most Renaissance and Baroque pictorializations of God, the most famous being Michelangelo's depiction on the ceiling of the Sistine Chapel.[4] The color and cut of the father's costume, the only one in the series that does not correspond to actual seventeenth-century Spanish garb, also befits his imperious status. He is represented in the first two paintings and in the last (fig. 6) wearing a tight-fitting skullcap and a floor-length purple robe. The father's elegant attire corresponds to the costume directions of the Golden Age playwright, Lope. In *El hijo pródigo,* as well as in Tirso de Molina's comedy *Tanto es lo de más como lo de menos,* the parent's name suggests his true identity. He is called Cristalio, or Crystal, in Lope's *auto sacramental* and Clemente in the comedy. The association is completed in Lope's script by costume directions requiring Cristalio to wear a long purple silk robe.[5] While the length and substance of the gown befit his age and dignity, the color declares his imperious alter ego. Purple, traditionally the shade of royalty, symbolized love for Golden Age writers.[6] An example of its use upon the stage occurs in Tirso's play *La republica al revés* (The upside-down republic), when the female protagonist Lidora identifies her purple dress as being the color of love. Lidora's maid Camila counters this claim by pointing out that purple also suggests sadness since it is the color of Advent and Lent.[7] For the roles that the father assumes in Murillo's series—as the aggrieved Deity who endures both his younger son's selfish demand of the portion and the son's departure and later the benevolent forgiver who receives his son back—the color is most fitting. Worn by the father, the purple robe could thus simultaneously represent the color of love as well as that of sadness.

Murillo's dedication of an entire composition to the second episode, the departure (fig. 2), is unusual in Western art. Renaissance artists commonly relegated this subject (Luke 15:13) to the background of the preceding scene, as in Maerten van Heemskerck's first woodcut in a series of four. Most Baroque artists omitted the episode alto-

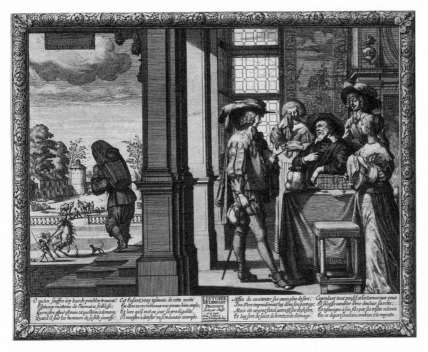

8. Abraham Bosse, *The Prodigal Son Bids Farewell to His Father*, mid-seventeenth century. B-33761. National Gallery of Art, Washington, Ailsa Mellon Bruce Fund.

gether, although a telling detail included in the preceding scene often alludes to it. For example, the presence of a saddled horse and baggage refers to the prodigal's exit in the first sketch of six sketches by the Bolognese artist Pier Cittadini (Windsor Castle), as well as the first engraving of a set of six by the Frenchman Abraham Bosse (fig. 8).

Murillo's unusual depiction of the prodigal's departure is based upon Jacques Callot's (1592/3–1635) second etching of his 1635 series (fig. 9). Like the Frenchman Callot, Murillo stages the parting outside the father's home. He also represents the elderly, bereaved parent struggling forward from the porch to detain his wayward son, whose servants and baggage, borne by pack animals, disappear into the left side of the composition. The prodigal, who mounts his horse in the print, is already in the saddle in the painting, bidding his disconsolate

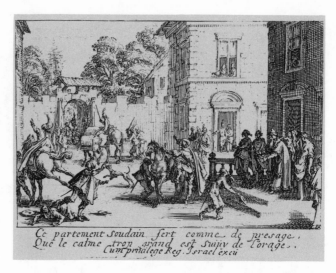

9. Jacques Callot, *The Departure of the Prodigal Son,* 1635.
(X1934–315E). The Art Museum, Princeton University.
Bequest of Junius S. Morgan.

family farewell with a dashing sweep of his fancy hat. The sorrowful
females beside the parent in the painting correspond to the weeping
women flanking him in the print.[8]

A striking difference between painting and print is the absence from
the latter of the elder brother. Although most Renaissance and Baroque
artists delete the brother from the scene of the prodigal's departure,
Murillo positions the sibling as prominently as in the first painting. He
appears beside the father in the right side of the composition, a wadded
handkerchief in his hand. Indeed, because the mounted prodigal is
turned away from the viewer, it is upon the steadfast elder brother that
one focuses. As in *The Prodigal Son Receiving His Portion,* it is the broth-
er's virtuous, noble character that Murillo directs the viewer to consider.

The playwrights Tirso and Valdivielso also feature the elder brother.
In their scripts he serves the important function of supplying a pious
counterexample to the sinful prodigal. Valdivielso in his *El hijo pródigo*
christens the elder brother Justino, a name meaning justice, which
befits his honorable nature. His prudence is highlighted in an unusual

scene in which, while dutifully tending his father's fields, he laments his sibling's rash departure in a long soliloquy.[9] More important, however, is the brother's role in *Tanto es lo de más como lo de menos.* Tirso's script, which synthesizes the prodigal's story and the parable of the rich man and poor Lazarus, promotes the elder brother Modesto as a prudent contrast to the excesses of three characters: the insolent prodigal, the rich glutton, and the starving Lazarus, reduced to beggary through overzealous charity. More than any character, the equanimous, unassuming Modesto embodies the moral of Tirso's play that perfection is found within the golden mean. As his play's title translates, "Too much is as bad as too little."[10]

Murillo likewise promotes the elder brother as the prodigal's pious opposite by contrasting the siblings' costumes. While the brother's simple attire of a gold-colored suit and flat-heeled slippers befits an honest, unassuming character, the sumptuous trappings of the prodigal—an elegant suit trimmed with gold buttons, a top hat adorned with a plume, and a fine sword with a golden hilt—expose a vain and pompous individual. In Western art, the excess of elegant accessories traditionally denominates the dandy. In fact, in Cesare Ripa's popular Renaissance emblem book, *Iconologia,* the figure of Il Contento, the self-satisfied one, is a richly dressed youth who sports a plumed hat and admires his reflection in a mirror (fig. 10). A similar dress code also appears in literature. Lope's early seventeenth-century comedy *La prueba de los amigos* suggests the prodigal Feliciano's foolish conceit by a pompous toilette that calls for him to "dress himself before a mirror held by a page, while a second servant holds his hat and cape. Meanwhile, Galindo (his lackey) dusts his hat. Two musicians sing while Feliciano arranges his collar."[11]

The color of the prodigal's dress in Murillo's painting is also significant in distinguishing the brothers. When the happy-go-lucky prodigal of Tirso's *Tanto es lo de más como lo de menos* has squandered nearly all of his inheritance, he informs his servant that he wishes to depart the courtesan's establishment attired in green and red (*encarnado*), the latter color conforming to his mood. Although Tirso does not specify the character's humor, red usually connoted joy for Golden Age authors. The prodigal's bright red cape in Murillo's second painting

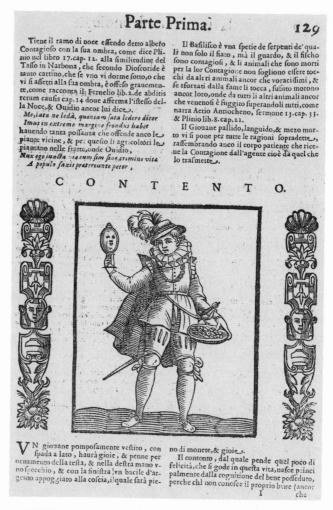

10. "Il Contento," in Cesare Ripa's *Iconologia,* Padua, 1625, page 129 (photo: Biblioteca Nacional, Madrid).

suggests that he is very merry at his departure, as befits his spendthrift mood.[12]

The green of the prodigal's suit is cited in another play by Lope, *El hijo pródigo*. This script, which requires the character to depart his father's home wearing a green traveling suit, probably employs the

color for its long-standing association with youthfulness and naïveté.[13] In Tirso's *Tanto es lo de más como lo de menos,* the prodigal's father refers to his son's green age; in Valdivielso's *auto sacramental,* the prodigal summons his servant, the personification of his own immaturity, by calling him "green Youth."[14] Murillo's color choice also may relate to the Castilian noun, *pisaverde.* Formed by combining the verb *pisar,* to step on, with the adjective, *verde,* green, the word is defined in Sebastián de Covarrubias's 1611 dictionary of the Spanish language, *Tesoro de la lengua Castellana,* as an empty-headed, finicky *galán* who walks on his tiptoes, as if crossing a manicured garden. In Valdivielso's *El hijo pródigo,* Pleasure, the prostitute's cohort, calls the character a *pisaverde:* "He is a *pisaverde* who loses himself through his prodigality."[15]

Another character flaw in the prodigal that distinguishes him from his virtuous brother is recklessness, and the prodigal's spirited horse suggests this flaw. The animal, whose eagerness for the journey is indicated in Murillo's painting by its raised foreleg, windswept forelock, and wild, gleaming eye, recalls a print illustration of a rearing stallion mounted by an elegant youth in Sebastián de Covarrubias's *Emblemas morales* (Emblems of morality) (fig. 11). Verses below the image explain that

> The young man, and the colt are spirited,
> And reins are needed, more than spurs.
> With little age, vigorous, lustful and furious
> In their race the one and the other fly.
> Tire them, never let them be idle.
> Control them in the field and in the school.

Lope invokes the same censorious parallel. In *El hijo pródigo,* Cristalio compares his son's reckless spirit to an accelerated horse that feels neither the rein nor the bit, and Juventud, the prodigal's servant, observes that Cristalio should lengthen his master's reins so that he might run well.[16]

The contrast that is made through expression and pose between the reckless, naive, and vain prodigal and his prudent, humble brother explains the presence of the reclusive women in Murillo's cycle. These unadorned ladies—the one who poses in the shadows in the first painting, the two who grieve beside the father in the second, and the one

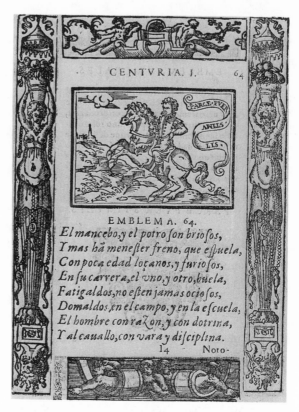

11. Emblem 64 in Sebastián de Covarrubias's
Emblemas morales, Madrid, 1610, page 64 (photo:
Biblioteca Nacional, Madrid).

who witnesses the prodigal's return in the last—offer pious counter-
examples to the wanton women of the third and fourth compositions.
Their modest dresses contrast dramatically to the low-cut neckline of
the bejeweled courtesans' brightly colored gowns, and their silent
comportment is the opposite of the prostitutes' bold, public behaviour.

The passive behaviour of Murillo's ladies conforms to that recom-
mended for good women by Spain's sixteenth- and seventeenth-
century moralists. According to these authors, most of whom were
members of celibate religious orders, the virtuous female should re-
main cloistered in her home, sheltered away from a world that she was

not equipped by God to understand. In his *Vida política de todos los estados de mujeres* (The politic life of women of all classes), a guidebook for virtuous women published in Alcalá de Henares in 1599, the Franciscan friar Juan de la Cerda argues,

> Why did God give women weak bodies with delicate members if not because he bred them not to travel but to stay seated in their corner? . . . And so God did not bestow on them the intelligence necessary for larger business matters, nor the strength necessary for battle or the field. . . . Just as men are created for the public life, so women for cloistering; and as it is the nature of men to talk and venture out in public, it is proper to women to be covered and cloistered.[17]

The modest attire of the women in Murillo's cycle includes scarves to cover their heads when stepping beyond the portal of the father's house (figs. 2, 6). In Seville, during Murillo's lifetime, this modest accessory was required of all good women who ventured beyond their homes. The anonymous author of an eyewitness record of Seville's plague of 1649 verified this when he commented upon the ladies who, forced to buy coal and other essentials, shielded their heads with only a cloth or small towel, rather than a mantle. He remarked that "such lack of concern during these years went undocumented whereas in other times it would have been considered indecent, or even delirious behaviour."[18]

The contrast Murillo creates between the modestly attired females of the first two paintings and the indecently outfitted women of the third and fourth paintings occurs in the writings of the moralists, as well as in scripts from the Golden Age. In his *Talentos logrados en el buen uso de los cinco sentidos* (Talents gained in the good use of the five senses), Jesuit Diego Calleja declared sumptuous accessories the "mark of the prostitute." The "mad woman" who dressed in rich clothes, jewels, and ribbons was accused by Calleja of vanity and loose morals. He contrasted this fallen one to the woman who dresses modestly and humbly, thereby indicating her honor to the world.[19] A similar contrast is created in Tirso's *Tanto es lo de más como lo de menos* by the prodigal's virtuous girlfriend, Felicia, and the greedy courtesans, Flora and

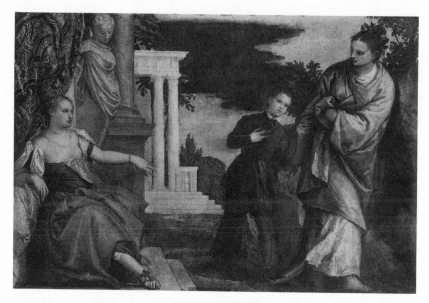

12. Paolo Veronese, *Youth Choosing between Virtue and Vice*, 1580. Museo del Prado, Madrid.

Taida. Lope often contrasted good and bad women in his plays and novels. He expressed the difference in *La prueba de los amigos* through Leonarda, the good woman the prodigal spurns, and Dorotea, the beautiful, but fickle, courtesan.[20]

The two types of women illustrated by Murillo personify the choice that the prodigal must make between virtue, or obedience to his father, and vice, the departure to a faraway land. The option was popular with Renaissance and Baroque artists, who often represented it in the guise of Hercules at the Crossroads and in the ancient hero's election of the female personification of virtue over that of vice. A related painting by the sixteenth-century Venetian Paolo Veronese, *Youth Choosing Between Virtue and Vice* (fig. 12), presents an elegantly attired youth deciding between a beautiful, bejeweled courtesan clad in a low-cut dress and an equally beautiful but modestly attired and completely unadorned female who takes his hand to lead him safely away.[21]

The grievous error that the prodigal makes by selecting the wrong

path was interpreted by Augustine as forgetfulness of God. He explained the wayward soul's misuse of its free will after creation: "The soul of man chose of its free will to take with it a certain power of its nature, and to desert Him by whom it was created, trusting in its own strength, which it wastes the more rapidly as it has abandoned Him who gave it."[22] How the prodigal squanders his substance in the company of the desirable but wicked courtesans is the subject of the third painting in *The Parable of the Prodigal Son*, *The Prodigal Son Feasting*.

3

The Fall of the Prodigal Son

Murillo's third painting, *The Prodigal Son Feasting* (fig. 3), connects the first two scenes in the narrative to the latter three. As the visualization of the prodigal's sin, the painting both illustrates the consequences of his initial error, the ill-chosen path, and explains the need for his subsequent repentance. Within the theological history of mankind, the event corresponds to the Fall: to the disastrous bite from the forbidden fruit taken by Adam and Eve in the Garden of Eden.[1]

Murillo's illustration of the prodigal's fall is unusual in two ways. First, the scene appears to be unique in Spain, where provocative, or lascivious, images were systematically avoided. Second, Murillo's version of the corruption is remarkably circumspect if compared to the interpretations of other European artists who reveled in the sensual possibilities of the event. In northern Europe, for example, the prodigal's banquet catered to the same taste that had popularized paintings of the senses. Five early seventeenth-century compositions by the Fleming Jan Brueghel (Museo del Prado, Madrid) illustrate the senses with a variety of objects associated with taste, touch, smell, hearing, and sight. Similarly, in Frans Francken's *The Prodigal Son Feasting* (ca. 1630; fig. 13), the sinner's carnal indulgence is elaborated to include a company of boisterous, intoxicated couples who converge at a table laden with a magnificent spread of oysters, cooked birds, fruit, and an ostentatious peacock pie. The prodigal embraces the willing courtesan

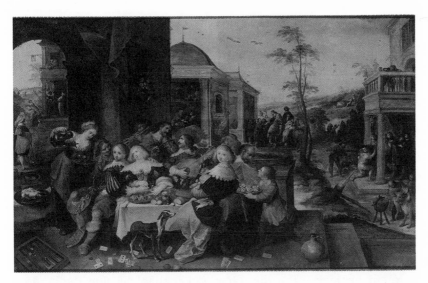

13. Frans Francken the Younger, *The Prodigal Son Feasting,* ca. 1630. Staatliche Kunsthalle, Karlsruhe (photo: A. C. L.).

to the musical accompaniment of a lute player, a violinist, and a knowing flutist. The sinner's sword rising perpendicularly between his legs and the old procuress who hawks her wares provide references to upcoming sexual activity.

Compared to the rowdy immodesty of Francken's scene, Murillo's feast of the prodigal is restrained. The Spaniard's interpretation is much more subdued, including only six figures. He depicts the scene as Luke describes it in verse thirteen: "and there wasted his substance in riotous living." The prodigal's brother further elaborates later, in verse thirty, that this occurred in the company of harlots, and Murillo incorporates these details into his painting. The prodigal and his sumptuously attired companion sit properly, even primly, at the center of the table. They are joined by two servants, a lute player, and the courtesan's handmaiden, who pose at one end of the counter, silently observing the pair. Perched on a stool in the shadows of the left foreground, the musician seemingly supplies the only sounds at this most sedate gathering. Notably absent from Murillo's tidy interior are Francken's allusions to fornication. Although the courtesan gazes

amorously into the prodigal's eyes, physically the pair barely touch; the prodigal's left arm only loosely enfolds his companion—his hand but lightly grazes her shoulder.

The banquet is as circumspect as the participants. Unlike the disorderly abundance of Francken's spread, Murillo's neatly laid meal proffers only two roasted fowl and a circular pastry. An entering servant bears aloft a second and more elaborate pie. In contrast to the plentiful wine of the Fleming's feast, only one goblet is evident in Murillo's painting: one from a salver that is tendered the prodigal by the servant posed on his right. Except for the knife, no silverware or plates are provided; the food and drink are untouched; the feast has yet to begin.

Murillo's modest banquet conforms to the feasts depicted by Peninsular painters, who uniformly establish the merits of an occasion through the identity of the diners rather than through the kind or quantity of their provisions. The meal served the glutton in Juan de Sevilla's late seventeenth-century painting *The Parable of the Rich Man and Poor Lazarus* (fig. 14) is no grander, nor more extravagant, than that proffered Christ in Murillo's *The Marriage Feast at Cana* (ca. 1670–1675; fig. 15). The Son of Man and His scriptural hosts are treated in the latter painting to two large pies, a roasted bird, and fruits. Comparably catered are the virtuous gatherings painted by Bartolomé Román (*The Parable of the Wedding*, 1628; Convent of La Encarnación, Madrid) and Miguel Manrique (*Feast in the House of Simon Levi*, mid-seventeenth century; Cathedral, Malaga).

The restraint manifested by the Spanish banqueting scenes may be related to the vice of gluttony. Gluttony, or the inordinate desire for food and drink, was of particular concern to Christian moralists.[2] In the fourth century St. John Chrysostom affirmed that gluttony turned Adam out of paradise and thereby declared that vice the root of all the world's evil.[3] The medieval scholar Thomas Aquinas (ca. 1225–1274) accepted this notion when he classified gluttony in his *Summa Theologica* with his final causes of sin—those that give rise not just to similar abuses, but also to a host of different ones as well.[4] In the case of gluttony, the most grievous of these was lust. As St. Gregory the Great observed in the sixth century and Aquinas reiterated in the

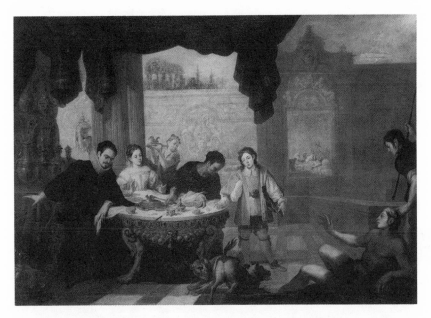

14. Juan de Sevilla, *The Parable of the Rich Man and Poor Lazarus,* late seventeenth century. Museo del Prado, Madrid.

thirteenth century, "When the belly is distended by gluttony, the virtues of the soul are destroyed by lust."5

The perils that Christian theologians ascribed to gluttony were said to derive from the vice's abundant pitfalls. Aquinas declared that one could incur gluttony in five ways: by seeking foods too costly, requiring that foods be too daintily prepared, eating too greedily, forestalling the hour of need, and exceeding necessity in quantity of provisions. The prodigal of Murillo's third composition is guilty of three of these. Represented in *The Prodigal Son Feasting* are the first two infractions of kind, as well as the last of quantity.

The mealtime intemperance represented by Murillo is one of the excesses cited by the Spanish reformer Christóbal Pérez de Herrera as contributing to the economic decline of the kingdom in the seventeenth century. Pérez de Herrera argues in his 1617 pamphlet that a legal limit should be set on the number of dishes allowable at any given feast.6 This prudent sumptuary measure was ignored by the monarch

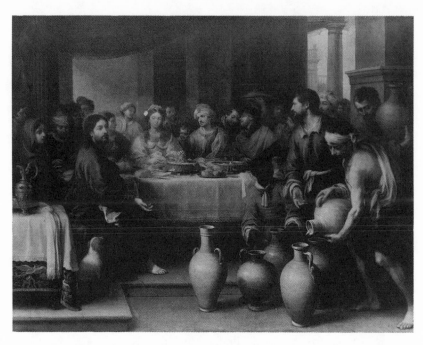

15. Bartolomé Esteban Murillo, *The Marriage Feast at Cana,* ca. 1670–1675.
The Barber Institute of Fine Arts, The University of Birmingham.

Philip III, whose exquisite palate is documented by the then-popular
cookbook of his palace chef, Francisco Martínez Montíño. In his
Arte de cocina, pastelería, vizcochería y conservería (The art of cooking,
confectionery, baking cakes, and making preserves, 1611), Martínez
Montíño supplies recipes for the roasting and stuffing of birds of
every variety, as well as for the preparation of richly seasoned pastries
filled with snails, calf brains, or javelin. The entrees for the elaborate
September meal, one of several three-course dining experiences elab-
orated by Martínez Montíño, are as creative as young pigeons stuffed
with pumpkin and as fanciful as rabbit turnovers shaped like lions.[7]

Spanish theologians condemned the elaborate and delicately sea-
soned dishes of such cookbooks as promoting gluttony. In his emblem
book, *Empresas espirituales y morales* (Spiritual and moral emblems,
1613), the prior of Javalquinto, Juan Francisco de Villava, declares,
"The friends of [gluttony] are the enemies of nature since the foods

that she provided, simple and sound, they adulterate and corrupt. This, be advised, is what the books of cookery pretend to do, that no food retain its proper and natural flavor but, rather, that everything should be confused and out of order."[8] Moralists who supported Villava's argument traced man's dining habits back to a simpler and more virtuous time. Sebastián de Covarrubias, for example, illustrates this history with an emblem depicting swine eating acorns at the base of an oak tree (fig. 16). He explains the emblem as follows:

> It is accepted that at the beginning of the world men sustained themselves with plants, and fruits, particularly of the oak tree . . . but as time passed they began to make use of animal flesh, and birds and fish. And not content with eating these roasted and cooked, have come to invent so many different stews and potages that they seem to have no more reason than to invent gluttony. That from this follows sicknesses, death, poverty and a multitude of vices is only too obvious.[9]

The foods that Covarrubias proscribes—namely, meat, fowl, fish, and dishes produced from a combination of ingredients—are the very ones depicted by Murillo in *The Prodigal Son Feasting*. While the meticulously laid table displays two roasted fowl and a circular pastry, the entering servant delivers another mixed dish, the decorated pie.

Surely Murillo's principal reason for including the elaborate pie topped by the figure of a tiny, armed soldier is to underscore the wicked indulgence of the scene. In this gluttonous feast, the entering pastry is the only food that does not find its recipe in Martínez Montiño's cookbook. The author's promise that in a forthcoming book he will provide some "fantastic [dishes], suitable for banquets, those conceived more for the sake of curiosity, and ostentation, than necessity," suggests that such fanciful concoctions at least occasionally graced well-laid Spanish tables.[10] Indeed, a recipe for a malleable, form-holding dough shaped by a mold that can produce a figure of an armed man is provided by Miguel de Baeza in his book of dessert recipes, *Los quatro libros del arte de la confitería* (The four books of the art of confectionery, 1592).[11]

The intricate recipe supplies a pastry so exquisite that in Murillo's painting it announces the prodigal's fall by emphatically defining him

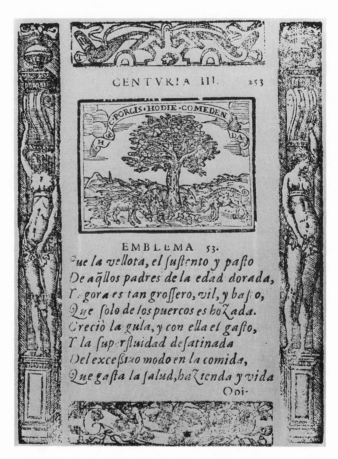

16. Emblem 53 in Sebastián de Covarrubias's *Emblemas morales,* Madrid, 1610, page 253 (photo: Biblioteca Nacional, Madrid).

as a glutton. In the painting, allusions to the sinner's other four senses accompany his abuse of his sense of taste by gluttony. Following a format usually associated with northern-European representations of the prodigal's feast, including Frans Francken's aforementioned painting, Murillo also presents the abuse of the sinner's senses of sight, hearing, touch, and smell.

Seventeenth-century Spanish theologians believed that God awarded man his senses so that he might negotiate his salvation. To achieve

spiritual union with God, the Christian zealot traveled the *via mistica*. This three-part journey comprised the *vias purgativa, illuminativa,* and *unitiva* and was methodically outlined in the thirteenth century by the Carthusian Hugh of Balma (*De Theologia Mystica*). Visionaries who undertook the spiritually demanding journey were guided by manuals, including *Arte de bien vivir y guía de los cielos* (The art of good living and a guide to heaven), a ponderous two-part treatise composed by the Benedictine abbot Antonio de Alvarado (1561–1617). Laymen aspiring only to the first *via, purgativa,* which achieved the domination of the senses through denial and prayer, looked to more compact publications, such as *El desengañado* (The undeceived one, 1663), written by the Salamancan bishop Francisco de Miranda y Paz.

The spiritual guidebooks of these learned authors corroborate the prodigal's misuse of his God-given senses, which leads to his fall. Sight, his most precious sense, he abuses by gazing at the courtesan. Alvarado advised Christians who truly wished to serve God to "guard this door, or window, to the castle of the soul as through one's eyes one's enemies enter to rob one of the spiritual treasure of the soul." Because it is through his sight that the "disordered love of some prohibited object [the courtesan] has entered and robbed him of that precious trove of grace and spiritual love," the prodigal has abused the sense.[12] As Miranda y Paz explained, "God does not forbid that one look at the unattached woman [the courtesan], he forbids one to desire her. It is not good to look at what one shouldn't desire as one quickly passes from sight to desire, and hence to the illicit means necessary to obtain that which one desires."[13]

The pleasing notes of the lute player tempt the prodigal's sense of hearing in Murillo's third painting. Theologians of the seventeenth century understood music as a potent force capable of altering the listener's heart and soul, of pacifying or elating, of strengthening or saddening. Alvarado advised the true servant of God to treat all music with care and to avoid those melodies that only delight the ear. He promised that this aural mortification would be rewarded in heaven with the glorious harmonies of the angelic choir, music that lasts an eternity.[14]

While Alvarado did not consider music inherently evil (he classified its sounds as neither good nor bad, but as indifferent), he regarded it as exceedingly perilous when offered in association with the charms

of a beautiful lady. The singing of women, even if of good and saintly things, is particularly to be avoided, he warned, as it carries a poison that perturbs the sense of hearing and inflames the heart with lascivious desires.[15] An emblem (fig. 17) of a beautiful mermaid playing a stringed instrument and included in Juan de Horozco y Covarrubias's *Emblemas morales* (Devices of morality) illustrates the theologian's words. Derived from Homer's tale of Ulysses tempted by the sirens, Covarrubias offers the emblem as a pictorial metaphor for vice that tricks and entraps a man with its beautiful appearance and sweet song.

The beautiful courtesan is also the cause of the prodigal's abuse of his sense of touch. By folding his arm around the woman, the sinner disregards Alvarado's caution to his male readers that to control touch, the source of all carnal desire, one must refrain even from feeling the hands or faces of young women and adolescents.[16] The more exacting Miranda y Paz declared that man should avoid any and all physical contact. Explaining that, of all the senses, only touch is ceaselessly active, he declared that with it there could be no negotiation.[17]

Murillo accounts for the remaining sense of smell that one abuses when "using it sensually, to delight and incite one's carnal desire" by the aroma of the freshly laid meal and the bouquet of the wine.[18] Moreover, by banqueting in an open-air patio, the prodigal is relishing the sweet fragrances of nature. These scents enjoyed in the company of the alluring courtesan recall the fate of the character of Man in Calderón de la Barca's *Los encantos de la culpa* (The delights of sin). In this mid-seventeenth-century allegorical script, the bewitching temptress Sin uses perfumes in the garden of delights to intoxicate hapless Man's sense of smell and achieve his downfall.[19]

Seventeenth-century Spanish moralists agreed that man's senses were subject to his governance since "although they seem free, they are faculties subordinate to one's will."[20] Defeated by his baser passions, the prodigal of Murillo's painting is no better than the tiny spotted spaniel peeking out from under the tablecloth, its eyes expressing wild greed over the bone gripped between its teeth. Emblem thirty-one of Juan de Borja's *Empresas morales* (1581) compares a dog dragging its chain to a man so riddled with sin that he is like a captive

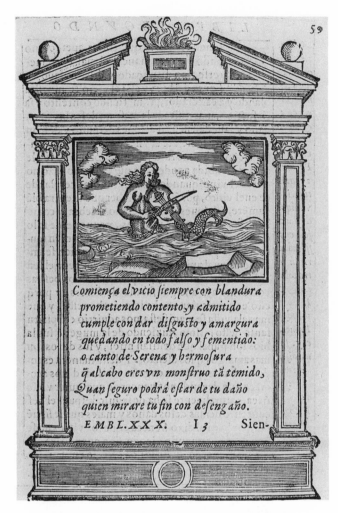

17. Emblem 30 in Juan de Horozco y Covarrubias's
Emblemas morales, Segovia, 1589, page 59 (photo:
Biblioteca Nacional, Madrid).

until he rids himself of his vices and the opportunities to repeat them.[21]
Similar is the emblem (fig. 18) in Covarrubias's *Emblemas morales* that
compares a gluttonous dog, reingesting its own vomit, to the peni-
tent soul who, having given up a vice, sins again, forgetting both God
and his conscience.

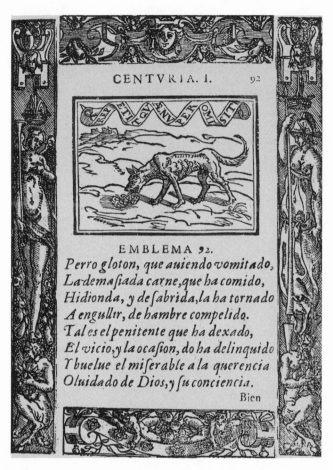

18. Emblem 92 in Sebastián de Covarrubias's *Emblemas morales,* Madrid, 1610, page 92 (photo: Biblioteca Nacional, Madrid).

The sinful behaviour that Murillo details in his third painting reminds the Christian viewer of the eternal consequences of vice. This subtle message is more clearly stated in Ignacio de Ríes's 1653 painting *Tree of Life* (fig. 19, Segovia Cathedral). Ríes's large canvas depicts a festive gathering of elegant couples seated in a tree. Accompanied by music makers, the irresponsible merrymakers embrace and imbibe around a table covered with platters of meats and pastries. Below the

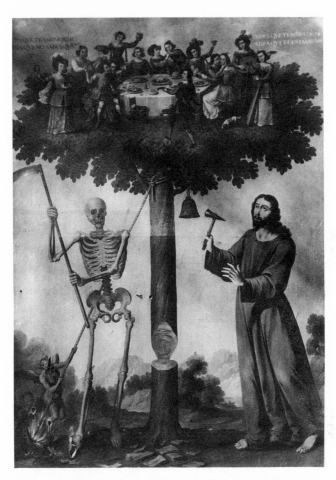

19. Ignacio de Ríes, *Tree of Life*, 1653. Cathedral, Segovia
(photo: MAS).

gathering stand the large figures of Christ, who is ringing a bell of
warning, and a skeleton, who is chopping down the tree. A rope tied
around the trunk and pulled by a small demon shortly will topple the
tree and all its tiny, sinful inhabitants into the bowels of hell. Inscribed
across the top of the painting is the prophetic warning, "Beware, you
too will die, / beware, you know not when. / Beware, God is watch-

ing you, / beware, He sees you." The message is clear. It is a caveat to Christian viewers to mend their ways or else be doomed.

While Ríes's painting clarifies the ultimate price of the prodigal's transgressions, still unexplained is how this sinner's vulnerable senses initially trip the controlling factor of his own will. The Golden Age scripts of Lope and Valdivielso suggest that the solution resides in the goblet of wine lifted from the salver by the prodigal. This vessel's importance is established in the oil sketch (fig. 20) by its exaggerated size, and it retains its significance in the painting because the prodigal is the only character provided with wine.

Called the wine of *olvido*, or forgetfulness, in Lope's *El hijo pródigo*, the crucial potion robs the prodigal of his memory and leads to his downfall. While characters personifying the vices encourage the sinner to drink, musicians sing "With the wine of forgetfulness / they have taken his memory: / he no longer remembers heaven, / center in which the soul reposes."[22]

In Valdivielso's *El hijo pródigo*, the potion becomes synonymous with the carnal pleasures offered by the courtesan. Carrying the tempting drink within her chalice, Lasciviousness appears upon the stage arrayed as the biblical nemesis in Revelations, the Babylonian Whore. The dandy Pleasure introduces her

> to the tune of sweet lutes,
> zithers, harps, guitars,
> the bewitching voices
> of beautiful sirens cry . . .
> covered in gold and pearls,
> she enters upon a beast,
> she who turns men into beasts,
> a chalice in her hand
> within which she carries her pleasures.[23]

The concept of man figuratively transformed into a beast through the wiles of a female corruptor also is present in Lope's plays *La prueba de los amigos* and *El hijo pródigo*. In the former, the prodigal's servant, Galindo, remarks that the courtesan Dorotea, a character subsequently compared to Circe and Medea, converts men into animals,

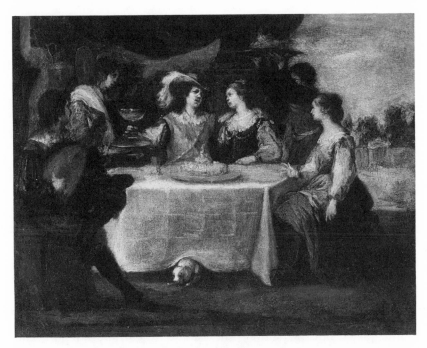

20. Bartolomé Esteban Murillo, *The Prodigal Son Feasting,* ca. 1660–1670. Museo del Prado, Madrid.

while in *El hijo pródigo,* Lope compares the intoxicated prodigal to the legendary Ulysses to underscore how the prodigal's indulgence will brutalize him.[24]

The concept of man debased by sin is central to a score of seventeenth-century Spanish plays, including Calderón de la Barca's *Los encantos de la culpa.* In this allegorical script by Murillo's famous contemporary, the character of Man falls asleep, relaxing his guard over his five senses. They are bewitched by the beautiful temptress Sin and are transformed into beasts, sight becoming a tiger, touch a bear, taste a speechless brute, smell a lion, and hearing a chameleon, conditions from which only Man, armed with his understanding, can rescue them.[25]

The Golden Age play that develops the prodigal's sin in a manner most like Murillo is Lope's *El hijo pródigo.* The script requires a servant to enter bearing a light supper, a musician to strum a lute, and

the prodigal, holding hands with the courtesan Delight, to drink the wine of forgetfulness. Meanwhile, a chorus intones

> Blind is his understanding,
> his will is impassioned,
> over his five senses
> Pleasure has been victorious.
> Pleasure, highwayman
> of fortune and honor,
> her eyes are on his. . . . [26]

The painting neatly visualizes Lope's words. While the prodigal takes his drink with his right hand, his left arm encloses the courtesan and draws her to his side. She looks amorously into his eyes. At first he appears to return that gaze, but closer inspection reveals that the prodigal, whose pupils are painted an opaque grey, stares dully into space, as if in blindness.

The interpretations are so similar that one must question whether Lope's play is not the painter's ultimate source. Interpreting a scene for which no native precedent existed and for which northern-European versions, while abundant, surely seemed immodest, Murillo may have looked to the work of Spain's finest Golden Age dramatist for inspiration. Equally subject to the strictures of the Inquisition, Lope's allegorical play offered a solution, a way of representing the prodigal's indulgence with restraint and circumspection. One can reasonably argue that this discreet Spanish script—along with the subsequent paintings that present the prodigal's redemption through his awareness of his sin, his repentance, and his absolution—made possible the first Spanish illustration of the prodigal's feast.

4

Desengaño, Repentance, and Absolution

The prodigal's spiritual transition occurs in the series's fourth painting. While Murillo's first three compositions record the prodigal's fall from grace, the fourth, *The Prodigal Son Driven Out,* illustrates his apprehension of his sin through his awakening, or *desengaño,* to life's manifold vanities. The last two canvases, *The Repentance of the Prodigal Son* and *The Return of the Prodigal Son,* document the curing of his spiritual ills through the Catholic sacrament of penance. *The Repentance* depicts the miserable sinner's sorrowful confession on one knee before God. *The Return* depicts the cleansing absolution granted him by the embrace of his welcoming father.

Murillo's fourth painting illustrates an event which has no actual basis in Luke's parable. For this reason, artists either ignored the dismissal or relegated it to the background of the preceding banquet scene, as in the engraving by the sixteenth-century Flemish printmaker Justus Sadeler. The prodigal's dismissal is also illustrated in Francken's busy painting (fig. 13) as the first episode in the left background. With few exceptions, only those Catholic artists who created large series of six or more illustrations of the gospel story dedicated an entire composition to the dismissal. In the seventeenth century, the prodigal's expulsion is represented in a painting by the Neapolitan artist Jusepe Simonelli (Palace, Aranjuez), a drawing by the Bolognese artist Cittadini (Windsor Castle), and a print by the Frenchman Callot.

Murillo's interpretation of the event (fig. 4) clearly follows Callot's

51

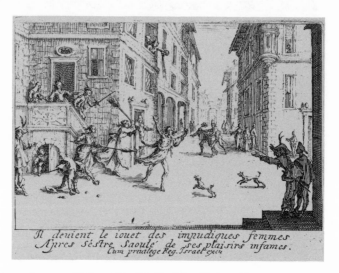

Il deuient le iouet des impudiques femmes
Apres s'estre saoule de ses plaisirs infames.
Cum priuilege Reg. Israel excu

21. Jacques Callot, *The Prodigal Son Driven Out*, 1635.
(x1934–315I). The Art Museum, Princeton University.
Bequest of Junius S. Morgan.

tiny etching of 1635 (fig. 21). In both, the frightened prodigal, dressed in
the rags of his earlier finery, is chased away from the house of pleasure
by two angry and violent young courtesans, one armed with a broom
and the other with a stake. Also enlisting in the eviction is a dandily
dressed gentleman wearing a plumed hat and brandishing a sword. As
the panic-stricken sinner, his arms thrown wildly up in the air, races
ahead of the menacing band, a small, ill-tempered dog (in Murillo's
composition, probably the same one that earlier gnawed upon a bone)
leaps in the air beside him. Absent from the etching is the wizened
crone who peers from a darkened doorway in the left-hand side of
Murillo's painting. In one hand she clutches a stick, and she raises the
other hand to point a warning finger toward the fleeing prodigal.[1]

The pell-mell flight of the prodigal visualized by both Callot and
Murillo agrees with the commonsensical advice offered to the faithful
by contemporary theologians and moralists: flee from sin. They coun-
seled their readers, weak human creatures easily tempted into the
abyss, to secure their souls by avoiding all situations that afforded the

opportunity to sin. The Benedictine monk Alvarado, in his *Arte de bien vivir y guía de los cielos,* instructed the scrupulous servant of God to elude not only mortal sin, whereby one loses grace, but also venial sin, which disgusts and offends Him.[2] In popular literature the concept appears illustrated in Otto Vaenius's *Theatro moral de la vida humana* (1672). Vaenius's emblem book, which was published first in Latin, in 1607, was translated into the Spanish language in 1669. Vaenius's print presents the goddess Athena leading an elegantly attired youth who is prudently absconding from a host of personified vices (fig. 22). The edition of 1672 includes the following commentary: "Virtue is found in fleeing from vice . . . we have already seen how weak and imperfect we are, and with what ease we allow ourselves to be taken in by nature's corruptions. We have also seen that it is not impossible to conquer and restrain our natural inclinations. It is prudence to flee from the army of vice so as to later conquer [its soldiers] one by one."[3]

As the fearful prodigal unwittingly complies with the advice of the moralists and departs the wicked harlots, his panicked eyes meet the sinister gaze of the withered hag who points the index finger of her left hand in his direction. The crone's appearance in an illustration of the prodigal's dismissal is exceptional in Western art. Although an aged procuress is often present in sixteenth- and seventeenth-century northern-European depictions of the feast, she invariably disappears before the youth's ejection. By drawing parallels to contemporary, moralizing literature, as well as by exploring interpretations of the scene by Spanish Golden Age playwrights, the crone will be shown to serve the essential and altogether different function in Murillo's series of expressing the sinner's *desengaño,* his spiritual awakening to the vanity of life's momentary pleasures.

Seventeenth-century European artists represented the transience of life's pleasures with telling still lifes in the popular pictorial genre of the *vanitas.* Spanish artists often expanded this format to include human or divine figures warning viewers to repent. One well-known example using this method is *The Dream of the Knight,* a painting attributed to Antonio de Pereda and dated circa 1650–1660 (fig. 23). This large Spanish canvas represents a dozing gentleman surrounded by assorted reminders of life's vanity, such as books, coins, and an extinguished candle. Disturbing his dream is a beautiful, silent angel carry-

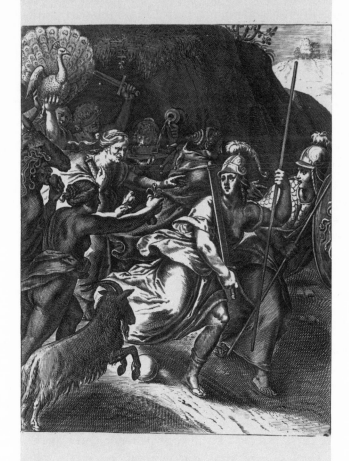

22. "Virtud es huir del vicio," emblem 6 in Otto Vaenius's *Theatro moral de la vida humana*, Brussels, 1672 (photo: Biblioteca Nacional, Madrid).

23. Attributed to Antonio de Pereda, *The Dream of the Knight,* ca. 1650–1660. Museo de la Real Academia de Bellas Artes de San Fernando, Madrid.

ing a banner whose Latin inscription, *aeterne pvngt—cito volat et occidit* (It pierces perpetually—flies quickly through the air and kills), reminds him of the brevity of this life and the eternity of the next.[4]

The angel's warning takes its cue from the Spanish moralists. These avid writers responded to their country's dramatic political decline in the seventeenth century by drafting scores of impassioned treatises discussing and describing the urgent topic of repentance. Their prolific writings clarify a crucial detail that the Council of Trent forgot when, in session fourteen, which opened November 25, 1551, the erudite churchmen discussed the solemn sacrament of penance. To wit, how does the morally bankrupt sinner ensnared by the pleasures of the flesh ever arrive at the remorseful state of contrition, step one of the sacrament of penance? Attentive Spanish theologians answered with the self-conscious experience of *desengaño.* The number of books published elaborating upon the state of *desengaño* is only suggested by some of the volumes that include the word *desengaño* in their titles:

El desengaño del mundo (1602), *Desengaños del mundo* (1611), *Engaños y desengaños del mundo* (1656), and *El desengañado* (1663).

The prevailing notion in Spain that to achieve contrition a sinner had first to undeceive himself of temporal vanities is also applied by Murillo and the Golden Age playwrights to the parable of the prodigal son. Lope's *El hijo pródigo* and Valdivielso's *auto sacramental* develop the prodigal's spiritual awakening through dialogue exchanged with his former companions during his expulsion from the house of pleasure. The foolish youth cries to the courtesan Pleasure in Lope's play,

> Oh house of confusion!
> When I brought my youth
> and my money here,
> your joy received me,
> your will opened before me.
> I consumed my youth,
> and spent my money
> in your delight, which was
> a crocodile for me; . . .
> Oh, vile Pleasure, and how poor
> are your feigned delights!
> You receive with [musical] instruments,
> but bid your farewells with blows.

Pleasure's handmaiden, Deceit, reminds the wailing prodigal that she did not trick him since he knew her name from the start. The saddened youth replies

> Youth
> has no greater fault
> than to see its own deceit, and follow it.[5]

Both Lope and Valdivielso create scenes remarkably similar to Murillo's fourth composition. Lope's stage directions require a tattered prodigal to depart the palace of Gluttony pursued by the courtesan and her handmaiden, who beat him with sticks.[6] Valdivielso's script calls for the temptress Lasciviousness, the dandy Pleasure, and the peasant, Olvido, or Forgetfulness, to beat a very broken, naked prodigal while the faithless Gaming urges that they loose a dog after him.[7]

Although neither play requires the presence of an old crone, dozens of other scripts could have inspired Murillo's use of this character. As the aged go-between Briana, the harridan appears in the earlier (1554) *Comedia pródiga* written by the clergyman from Caceres, Luis de Miranda. Within the Spanish theater also existed the immensely popular stock character of Celestina, a wrinkled, tricky go-between conceived by Fernando de Rojas for his immortal tragicomedy of 1499, *Comedia de Calisto y Melibea*. Rojas's play, commonly titled *La Celestina*, spawned six principal sequels by different authors, and the colorful figure of Celestina recurs in sixteenth-century literature in the work of Lope de Rueda, Juan de la Cueva, and Gil Vicente, among others. In the seventeenth century the crone's popularity was such that in *La prueba de los amigos,* Lope could clarify the courtesan's plot simply by invoking her name. Attempting to persuade the prodigal's servant Galindo not to interfere in the trickery she and her mistress plot, the handmaiden Clara asks him whether he has read Rojas's *La Celestina*. Galindo replies affirmatively.[8]

In Murillo's fourth painting, the panicked prodigal is jarred from his pleasure-induced, spiritual slumber of the preceding scene. Rudely awakened, he flees from the house of the angry courtesans into the barren countryside beyond. Ignoring the fierce gaze of the woman in the lead, whose upswung broom promises painful blows, the disheveled youth looks back into the darkened doorway of the house of pleasure. His frightened eyes meet the evil, knowing gaze of the wicked hag. It is she who expresses the sinner's *desengaño*. Posed behind the comely harlots and gesturing toward the prodigal with her extended index finger, she reminds the foolish youth that the courtesans, while desirable today, shortly will be as she is now, vile and hideous.

The prodigal's precipitous flight delivers him to the desiccated landscape of the fifth scene, *The Repentance of the Prodigal Son* (fig. 5). According to Luke 15:15–19, after a great famine ravaged the land, the destitute sinner hires on with a citizen of that country to tend swine in the fields. Abandoned by all and reduced to eating the coarse fare of his filthy charges, the unworthy prodigal determines to return to his father—whose servants even had bread enough to spare—and humbly beg his forgiveness.

Murillo's version agrees with the mystical interpretation of the par-

24. Albrecht Dürer, *The Prodigal Son,* ca. 1496. B–6489.
National Gallery of Art, Washington, Rosenwald
Collection.

able decided by ancient Christian theologians. Following the venerable
writings of Ambrose, Chrysostom, and Augustine, Murillo presents
the kneeling sinner itemizing his transgressions to his almighty Father,
rather than to his temporal father.[9] Most Catholic and some Protes-
tant artists followed this understanding of the event, which appears
in art as early as 1496, in Albrecht Dürer's famous single-sheet engrav-
ing, *The Prodigal Son* (fig. 24). In the seventeenth century, the prod-
igal repents before God in paintings by the Flemings Francken (Musée

Haussant les yeux au Ciel aux cris il S'abandonne,
Et reclame Son pere affin quil luy pardonne.
Cum priuilege Reg. Israel excudit.

25. Jacques Callot, *The Repentance of the Prodigal Son*, 1635. (X1945-315m). The Art Museum, Princeton University. Bequest of Junius S. Morgan.

du Louvre, Paris) and Rubens (Konigliches Museum der Schonen Kunste, Antwerp), prints by the Frenchmen Callot and Abraham Bosse, and in a narrow canvas attributed to Murillo, *The Prodigal Amid the Swine* (ca. 1670; Lord Hirshfield, London).[10]

The kneeling prodigal of Murillo's fifth painting of the series strongly resembles the sinner of Callot's sixth etching (fig. 25). In both versions the character is turned toward the viewer at a three-quarter angle with his left knee bent to the ground and his right foot gracefully pointed outward. Beside him on the ground rest his hat and staff. Both Catholic artists, moreover, present the prodigal in the very act of confessing, as witnessed by his upturned countenance, his left hand lightly indicating his chest as if to say, "mea culpa," and his extended right arm recalling the classical gesture of the Roman orator with upturned palm and splayed-out fingers. The swine that appear on all sides in Callot's tiny print are concentrated in the right foreground of Murillo's painting, the larger ones in the foreground are eating from a shallow trough arranged at an angle to their keeper.[11]

The serene, trusting visage revealed by the sinner of Murillo's painting

carefully conforms to the dictums of the Council of Trent regarding the proper method of repentance. According to the sixteenth-century assembly, complete faith in God's mercy is a vital requirement of contrition, the first of the three steps in the restorative sacrament of penance. Contrition also demands an intense sorrow and abhorrence of the crime committed with firm resolve not to transgress in the future. The ensuing confession constitutes step two of the sacrament and requires diligently examining one's conscience and reciting all of one's mortal sins. The third and final step, penance, includes discipline either assumed voluntarily by the offender or assigned by his confessor, as well as punishment meted out by God.[12]

Murillo's painting supplies evidence that the prodigal is completing all three steps of the sacrament of penance. His true contrition is indicated by his trusting visage, as well as by the tear descending his cheek. According to the seventeenth-century Jesuit priest Diego Calleja, tears wash away the sinner's transgressions and make him as deserving in God's eyes as all the martyrs in all their torments.[13] The prodigal's ongoing confession fulfills step two of the sacrament, and the ravaged landscape that frames him indicates that he is accomplishing the third step, penance, through punishment meted out by God. The famine cited in Luke and interpreted by Augustine as the want of truth in the world implies the corporal and spiritual misery that the sinner must suffer to atone for his earlier, misconceived ways.[14] Murillo's painting suggests this penance by the ruined brick building rising behind the prodigal. This detail, which Murillo may have borrowed from Dürer's famous engraving (fig. 24), appears in the oil sketch for the painting (fig. 26).[15] The Sevillian emphasizes it in the finished painting, however, by the structure's dark and ominous entrance.

The contemptible sins for which the wretched prodigal makes reparation were defined in the preceding chapter as the abuse of his corporal senses. The prodigal's swine may embody his sins in the fifth painting. The ancient comparison between man and beast surfaces in Western literature as early as the Gospels, in the miracle of Christ curing the man possessed of evil spirits (Matt. 8:28–34; Mark 5:1–20; Luke 8:26–40). It also occurs in the poignant lament of Andrés Ferrer de Valdecebro's (1620–1680) prodigal, included in the Spanish friar's

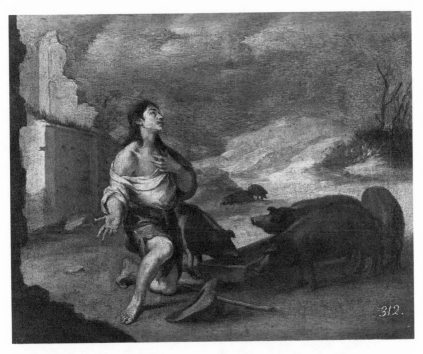

26. Bartolomé Esteban Murillo, *The Repentance of the Prodigal Son,*
ca. 1660–1670. Museo del Prado, Madrid.

brief exposition on proper repentance *Afectos penitentes de una alma
convertida con motivos grandes de bolverse a Dios* (Penitent expressions of a
converted soul with strong motives for turning to God). Ferrer de
Valdecebro's disconsolate prodigal cries, "From being the son of God
on high, I have sunk to the position of a slave of the devil; as my
reward . . . he has obliged me to feed the swine of my bestial appe-
tites and brute senses."[16] In popular Spanish literature, the parallel
between swine and sin appears in Juan Francisco de Villava's *Empresas
espirituales y morales* (1613). Villava interprets the image of a pig run-
ning from a church building (fig. 27) by declaring that, like the loath-
some animal, impious, profane individuals should not be admitted
into God's temples.[17]

By contritely itemizing his multiple transgressions to his spiritual
Father, the prodigal is purified. The sins he divests in Murillo's fifth

27. "Del Profano," in Juan Francisco de Villava's *Empresas espirituales y morales,* Baeza, 1613, page 50 (photo: Biblioteca Nacional, Madrid).

painting depart his soul to enter the repulsive bodies of the swine beyond. Suggestive of the prodigal's recouped grace is the natural light that softly bathes his kneeling person and contrasts boldly to the dark shadow falling across his unclean charges. As the ignorant animals absorb his spiritual burden, the prodigal readies himself to receive his spiritual reward of absolution.

Luke 15:20–24 records the awaited prize, the subject of Murillo's sixth and final painting:

> And he arose and came to his father. But when he was yet a great way off, his father saw him, and had compassion, and ran, and fell on his neck, and kissed him. And the son said unto him, Father, I have sinned against heaven, and in thy sight, and am no more worthy to be called thy son. But the father said to his servants, "Bring forth the best robe and put it on him; and put a ring on his hand, and shoes on his feet. And bring the fatted calf, and kill it; and let us eat, and be merry. For this, my son, was dead, and is alive again; he was lost, and is found." And they began to be merry.

Murillo's illustration of the joyous biblical event, *The Return of the Prodigal Son* (fig. 6), presents the remorseful sinner, covered in the tattered remains of his once-white shirt, kneeling before his benevolent father, who wears the long robe and skull cap of the first two paintings. The elderly parent is joined at the columned entrance to his home by four figures. From left to right, these silent witnesses to the reunion are the prodigal's unamused brother, who shields his body with a large, gold-colored cloak; an anonymous friend, who raises his hands in a gesture of wonderment; a diffident servant bearing the prodigal's new blue robe; and a young woman, who rests her body against the tall pillar supporting the house. Entering the courtyard through an archway located in the background on the right are two rustic figures: a peasant leading a calf and a woman bearing a basket of goods upon her head.

The father's warm welcome contains the moral to the first half of the parable: the repentant sinner's reward is compassionate forgiveness. For this reason virtually all visual narratives based upon the story include the episode of the return. The prodigal's reunion with his father is the fourth engraving in Bosse's series of six prints, the seventh etching in Callot's cycle, the central event of Francken's painting of 1633 (Musée du Louvre, Paris), and the sixth episode in Cittadini's suite of six drawings. The event also occurs frequently as an image by itself, notable examples being Lucas van Leyden's etching of

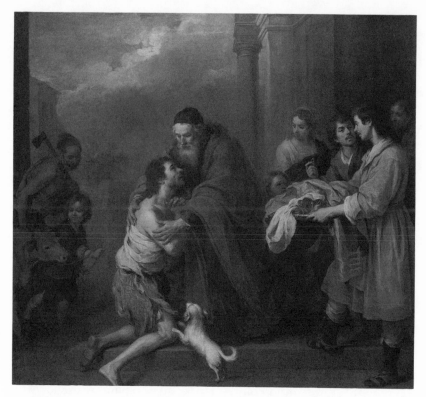

28. Bartolomé Esteban Murillo, *The Return of the Prodigal Son,* ca. 1668. National Gallery of Art, Washington; Gift of the Avalon Foundation.

1510, Rembrandt's famous painting of circa 1665 (The Hermitage, St. Petersburg), and Murillo's large-scale canvas of circa 1668 (fig. 28). The latter painting is one of six illustrating the Christian Acts of Charity, which were commissioned by Miguel Mañara for the decoration of Seville's Church of the Brotherhood of Charity.[18]

A striking difference between Murillo's large *Return of the Prodigal* and the scene as illustrated in the narrative series is the mesmerizing look exchanged between father and son in the narrative. In the small painting, the father's head is so close to his son's that their cheeks appear to touch. As the welcoming parent enfolds his kneeling offspring in his benevolent arms, he looks deeply into his son's large, clear, pleading eyes. The prodigal stares hungrily back.[19]

The hypnotic look exchanged between father and son is significant to the allegory of the series because it demonstrates the prodigal's proper use of his God-given faculty of sight. The dull, grey film that covered his eyes in the third painting when he misused the sense by impiously gazing at the courtesan is lifted to allow God's mercy to enter and fill his soul with light and truth. The Franciscan friar Alonso de Vascones explains in his 1619 moralizing treatise on *desengaño* and repentance, *Destierro de ignorancias y avisos de penitentes* (Banishment of ignorance and warnings for penitents), that "one's eyes," when virtuously employed, "are like windows through which light enters the soul, along with the truths taught us by our Holy Catholic Faith."[20]

What the prodigal must forbear seeing in this life, specifically the sinful delights of the third painting, he need not regret. According to the Jesuit priest Nicolás de Guadalajara, whose poem is appended to Lorenzo Ortiz's 1687 treatise on the senses, *Ver, oír, oler, gustar, tocar* (To see, to hear, to smell, to taste, to touch), the sinner's pious resistance will be rewarded in heaven when his eyes are filled with the eternal delight of the vision of God unveiled.[21] In Murillo's final painting, the prodigal's expectant eyes open wide to receive the vision of God the Father, represented by his elderly, welcoming parent.

The prodigal's material rewards also conform to the allegory of redemption. The spiritual significance of these gifts illustrated by Murillo was elaborated in the fourth century by Augustine. According to this Christian theologian, the prodigal's new robe represents the dignity that Adam lost, his ring signifies the pledge of the Holy Spirit, his shoes represent the preparation for preaching the gospel, and the fatted calf, which the father ordered sacrificed for the redemption of the sinner, symbolizes Christ Himself.[22] In his book of 1675, Ferrer de Valdecebro reworded the Latin father's text to read that God asked his servants, the angels, to dress the prodigal in the cloak of grace, to place on his finger the ring representing the hope of salvation, and to give him shoes which, like rays of light, will allow him to understand his past life. Then God invited the penitent soul to the miraculous feast of communion, a repast the sinner should partake of daily to achieve salvation.[23]

José de Valdivielso gives the robe and calf similar interpretations in *El hijo pródigo*. This playwright's didactic script identifies the prod-

igal's new apparel with the nuptial dress he must don to wed Christ, and he equates the fatted calf with the holy sacrament of communion. Prior to the prodigal's return, the allegorical figure of Inspiration alludes to the mysterious feast in which the Catholic church believes the wafer and wine are transubstantiated into the very body and blood of Christ. Inspiration thus details its benefits for the sinner:

> He [Christ] regales you with forgiveness;
> adhere to Him, and remember
> that your forgiveness was His death,
> and His death your life.
> For you to eat following your exile
> your father has Him;
> Come feast of the calf
> that nourishes the entirety of heaven.[24]

In Murillo's final painting, therefore, the prodigal's redemption is expressed in two ways. While the new robe alludes to his recovery of individual grace, the fatted calf symbolizes Christ's sacrifice on the cross for the salvation of all mankind. In his *Psalmodia eucharística* (1622), the Mercedarian Melchior Prieto (1578–1648) assured readers that the feast of Holy Communion would satiate the prodigal in a manner that the earlier, corporal feast with the courtesan could not. As Prieto explained, the parable of the prodigal son aptly illustrates that man's great spiritual hunger can be satisfied only by the heavenly banquet of communion, with all other feasts leaving him famished and needy.[25]

The lesson that the prodigal learns through his corporal and spiritual suffering brings him full circle in Murillo's final painting. The prodigal returns to the godly home and loving father he so foolishly rejected in the scene in which he takes his portion. The reappearance in Murillo's sixth painting of all four characters who introduced the series underscores the sinner's evolution. Especially notable in this regard is the presence of the elder brother who, silently observing the prodigal's reunion with his father, serves no apparent function. From the spendthrift, selfish dandy of the first three paintings, the prodigal has metamorphosed into a poor and humble servant of God. He has atoned for his sins, recovered God's grace, and his redemption is complete.

Part II

The Life of Jacob

5

Visual Sources, Patron, and Allegory

urillo's *The Life of Jacob* (figs. 29–32) is more difficult to interpret than is *The Parable of the Prodigal Son*. Unlike the foregoing series, *The Life of Jacob* contains no apparent moral. Its monumental canvases illustrate select episodes from the patriarch's long biography in Genesis, beginning with Jacob's usurpation of the blessing and ending with his confrontation with his father-in-law, Laban. Scholars have questioned Murillo's unusual choices of scenes, which seem to deny the cycle a proper closure. Their search for *The Life of Jacob*'s unifying logic is complicated by the series's unclear origins. Murillo's five dispersed canvases are believed by many to have been commissioned by Seville's Marquis of Villamanrique, a persuasive, but as yet undocumented, theory. This chapter will investigate how Murillo's choices of scenes relate to other, contemporary illustrations of the biblical story. The curious tale of the commission will be examined in order to determine the likelihood that Murillo and his patron conceived *The Life of Jacob* to conform to the popular Counter-Reformation allegory of the triumph of the Catholic faith.

Murillo's magnificent paintings, first documented in 1787 by Richard Cumberland (1732–1811), were studied in the twentieth century by Wolfgang Stechow. The traveling English playwright Cumberland, who saw the five canvases hanging together in the Madrid palace of the Marquis of Santiago, declared in his *Anecdotes of Eminent Painters in Spain, during the Sixteenth and Seventeenth Centuries* (London, 1787)

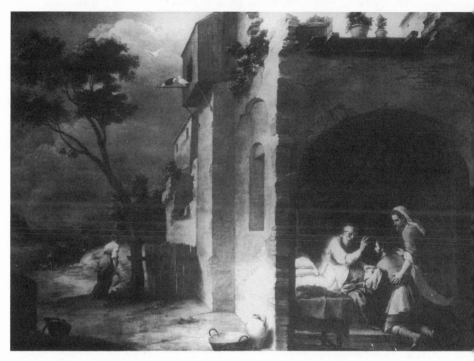

29. Bartolomé Esteban Murillo, *The Blessing of Jacob*, ca. 1660–1670. The Hermitage, St. Petersburg (photo: MAS).

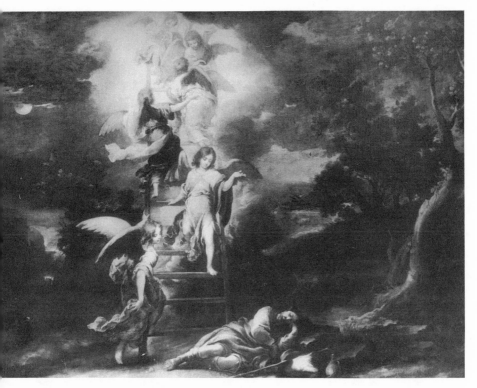

30. Bartolomé Esteban Murillo, *The Dream of the Ladder,* ca. 1660–1670. The Hermitage, St. Petersburg (photo: MAS).

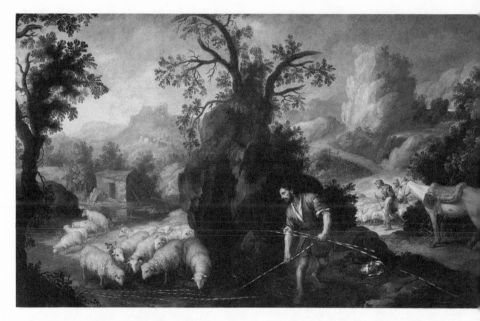

31. Bartolomé Esteban Murillo, *Jacob Laying the Peeled Rods before the Flocks of Laban*, ca. 1660–1670. Algur H. Meadows Collection, Meadows Museum, Southern Methodist University, Dallas, Texas.

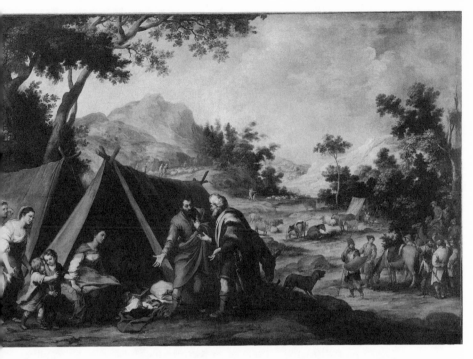

32. Bartolomé Esteban Murillo, *Laban Searching for His Stolen Household Gods in Rachel's Tent,* ca. 1660–1670. The Cleveland Museum of Art, gift of the John Huntington Art and Polytechnic Trust, 65.469.

that he preferred the paintings to all he had seen, excepting only Titian's *Venus*.[1] In 1967 the art historian Stechow pondered *The Life of Jacob*'s unifying principle. His fruitless search for the series's underlying logic led him to conclude that the individual episodes were elected purely on the basis of their landscape settings.[2] But Stechow's theory, which he offered only reluctantly, fails to account for *The Blessing*, an indoor event, and *Laban Searching for his Stolen Household Gods*, the cycle's relatively obscure fifth episode. Jacob and Esau's reunion, a more familiar event, which also occurred in a landscape, might easily have been substituted for Laban's search to furnish a closure to the sibling rivalry initiated in *The Blessing*.

If landscape were the unifying principle of Murillo's series, which clearly it is not, the range of scenes from which he could choose would have been very great indeed. For suggestions, Murillo could have turned to tapestry series and illustrated Bibles. *The Life of Jacob*'s five represented episodes, along with most of the rest of the patriarch's story, occur in a set of ten Flemish tapestries created circa 1534 by the famous Brussels weaver Willem de Kempeneer (Musées Royaux, Brussels).[3] Murillo might have seen Kempeneer's excellent weavings during a 1658 visit to Madrid, where the tapestries were documented in the Spanish Royal Collection.[4] The painter also could have known the anonymous woodcut illustrations of the Latin-language Bible, *Biblia Sacra*, published in Basel in 1578. The five sketchy images that correspond to the paintings are presented in uninterrupted sequence in the book's chapters of Genesis. Murillo's knowledge of the Bible is implied by an unusual detail of *The Laying of the Peeled Rods*—the copulating sheep of the right foreground (fig. 33). This remarkably earthy detail, which also appears in the print, apparently occurs in no other illustration of the scriptural episode.

Examples of all five events illustrated by Murillo also turn up in the small-scale canvases of the early seventeenth-century painter from Murcia (Spain), Pedro Orrente (1580–1645). Orrente, whose retables decorated churches in Murcia, Toledo, and Valencia, specialized in the representation of biblical stories in landscape settings conceived as "adornment for the rooms of wealthy gentlemen."[5] His canvases, which reflect his study with the Bassani family of painters in Venice,

33. *The Laying of the Peeled Rods,* in *Biblia Sacra,* Basel, 1578, page 31 (photo: The Department of Special Collections, Kenneth Spencer Research Library, University of Kansas).

present a variety of humans and animals engaged in assorted activities in luxuriant landscapes. Orrente's paintings were quite popular in the Peninsula. As Palomino remarked in *El museo pictórico y escala óptica,* in the eighteenth century there were so many paintings based upon the scriptures by Orrente in Spain that it was impossible to cite them all.[6] Whether a cycle once existed by Orrente that included all five scenes elected by Murillo is unknown. However, the following two chapters of this study will show that for at least two of Murillo's compositions, the influence of Orrente is clear: *The Blessing of Jacob* strongly resembles the older painter's 1612 version in Florence's Contini-Bonacossi Collection and *Laban Searching for His Stolen Household Gods* follows Orrente's important canvas of the same title in Madrid's Prado Museum (fig. 34).[7]

While no contemporary records document Orrente's paintings, they do explain an Old Testament cycle of paintings by Murillo. Chronicled in the second volume of Palomino's treatise is the unusual tale of the Marquis of Villamanrique's commission for an Old Testament series of paintings awarded jointly to Murillo and his Sevillian contemporary, the landscape artist Ignacio Iriarte (d. 1685):

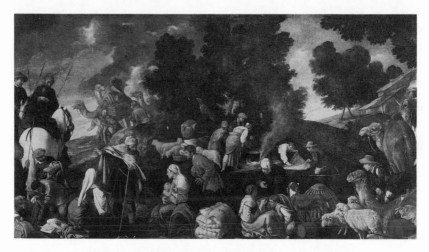

34. Pedro Orrente, *Laban Searching for His Stolen Household Gods,* early seventeenth century. Museo del Prado, Madrid.

> One should not omit the celebrated ability that our Murillo had for rendering the landscapes of his history paintings. And so it transpired that the Marquis of Villamanrique determined to commission a group of paintings based upon the life of David, from Murillo, with landscapes by Ignacio Iriarte. Murillo said that Iriarte should first compose the landscapes to accommodate the figures. The other said that Murillo should paint the figures and he would then create the landscapes. Angered by these arguments, Murillo said to him that if he thought that he required his talents for the landscapes, that he was deceiving himself; and so he alone produced the said pictures, with their histories and landscapes, marvelous works. And the aforementioned Marquis later brought them to Madrid.[8]

The scriptural cycle cited by Palomino is probably identical with *The Life of Jacob.* Most scholars support this identification, which explains the absence of any and all Murillo paintings of David. First to correlate the two cycles was Cumberland, whose information derived from *The Life of Jacob*'s eighteenth-century proprietor, the Spanish Marquis of Santiago. Cumberland's familiarity with this proprietor's records led him to declare that, following the break-up of the collab-

orative effort as recorded by Palomino, Murillo elected to illustrate
Jacob's life rather than David's.[9] Evidence in favor of Cumberland's
explanation is provided by the leading authority on Murillo and his
art, the late Diego Angulo Iñiguez, in his monumental opus *Mu-
rillo*. Angulo cited the Sevillian chronicler Fernando de la Torre y
Farfán, who recorded two very large series of paintings with Old Tes-
tament subjects decorating the facade of the Marquis of Ayamonte's
(Villamanrique's) palace in 1665.[10] Torre y Farfán, who documented
Seville's festivities honoring the redecorating of the marquis's neigh-
borhood Church of Santa María la Blanca, stated that one series was
based upon Jacob's life and the other upon that of Abraham.[11] Ac-
cording to Angulo, the Jacob paintings are identical with Murillo's
extant series, and the canvases illustrating Abraham's life were by
Iriarte.[12]

Angulo's interpretation of Torre y Farfán's text is sustained by *The
Life of Jacob*'s immense scale and the comparative talents of the rival
painters, Murillo and Iriarte. Although most Spanish artists, includ-
ing Orrente, conceived their Old Testament series upon canvases of
relatively small dimensions, Torre y Farfán specifically noted the *gran
corpulencia*, or very great size, of the works displayed in 1665. How
well his comment corresponds to the massive dimensions of Murillo's
brilliant series whose individual canvases measure more than eight
feet by twelve feet! The author's diplomatic remark regarding the
unequal merits of the paintings displayed also supports Angulo's the-
ory. While Murillo is unanimously hailed as Seville's finest late-Baroque
painter, his contemporary, Iriarte, is classified as an adequate, but
minor, landscapist. Avoiding both names, Torre y Farfán observed
that although the paintings were created with equal spirit, in execu-
tion they varied markedly.[13]

If Angulo's interpretation is correct, then both the marquis and
Murillo must be credited with conceiving *The Life of Jacob*. Painter
and patron together must have developed the splendid series to con-
form to a unifying principle, here identified as the triumph of the
Catholic faith. Within this familiar, celebratory conceit Jacob serves
as a foil for Christ, and Rachel represents the church. Although to
this author's knowledge art historians have not yet applied the alle-

gory of the triumph of the faith to a narrative series of paintings based upon the Old Testament, they have identified it with countless other works produced in Catholic Europe during the Baroque period. The Flemish artist Peter Paul Rubens (1577–1640) interpreted it for one panel of his monumental tapestry series, *The Triumph of the Eucharist*, designed for Madrid's Convent of the Descalzas Reales (1628; in situ), and the Spanish court artist Claudio Coello (1642–1693) developed it both in his impressive painting *The Triumph of St. Augustine* (1664; Museo del Prado, Madrid) and in his canvas *St. Catherine of Alexandria Dominating the Emperor Maxentius* (fig. 35).[14] The theme was still popular at the turn of the century when Palomino represented the triumph of the church on one wall of the Monastery of San Esteban in Salamanca.[15]

Even so, it was in the dramatic, rather than pictorial, arts that the allegory of the triumph of the faith achieved its maximum popularity in Spain. Interpreting the scriptural stories as prefigurative of later events was a time-honored tradition throughout all of Christian Europe, dating back to the famous mystery plays of the Middle Ages. The popularity of this use of the Old Testament in Spain is testified to by a codex of ninety-six anonymous plays preserved in Madrid's National Library. Composed between 1550 and 1575, these scripts, perhaps identifiable with plays performed in Seville in the sixteenth century, illustrate the close symbolic relationship between Christ and the patriarchs.[16] Spanish playwrights of the seventeenth century interpreted the biblical stories as historical dramas or as prefigurations of the Eucharist in the popular *autos sacramentales*. Lope de Vega, the Golden Age's most famous dramatist, based his historical drama *El robo de Dina* (The theft of Dinah) upon the rape of Jacob's daughter Dinah, and Calderón de la Barca created an *auto sacramental* around the romance of Jacob's parents.[17] Written about 1658, Calderón's *Primero y segundo Isaac* (First and second Isaac) compares Jacob's father, Isaac, to Christ, and his mother, Rebecca, to the Virgin and Church.

The allegorical significance of the Old Testament patriarchs and matrons attributed by Calderón derives ultimately from the scriptural exegeses of St. Ambrose (ca. 340–397). Following methods developed in the patristic school of Alexandria, this fourth-century theologian

35. Claudio Coello, *St. Catherine of Alexandria Dominating the Emperor Maxentius,* ca. 1664–1665. Algur H. Meadows Collection, Meadows Museum, Southern Methodist University, Dallas, Texas.

interpreted the scriptural stories three ways: literally (or historically), morally (to guide the Christian flock through its daily living), and allegorically (to define the tales as prefigurative of New Testament events).

Ambrose's tropological, or moral, interpretation of Jacob's life was

enlarged upon in the sixteenth century by the Toledan cleric, Alonso de Villegas Selvago (1534/- ca. 1615). Part two of Villegas's copious, six-volume Bible commentary, *Flos sanctorum* (1583), contrasts the model lives of the patriarchs to the principal heresies of Islam, Judaism, Protestantism, and idol worship. Villegas, whose unilateral portrait of Jacob required him to justify the patriarch's four wives by interpreting them as symbols of the four parts of the world Christ invited to receive His gospel, postscripted his chapters on the righteous Jacob, with a ponderous sermon on the sins of Islam, whose practitioners are permitted to indulge with numerous wives and concubines.[18]

Theologians of the seventeenth century elaborated upon the spiritual significance of Jacob's story. The erudite churchman St. François de Sales (1567–1622), penned two poetic homilies on the emotive meeting between Jacob and Rachel and another on the episode of the blessing. Sales unequivocally declared, "Allegorically, Rachel . . . always represents the Catholic Church and Jacob, Christ."[19] The Jesuit preacher from Ponferrada (León), Diego de Baeza (1582–1647), likewise compared Jacob to Christ in the first volume of his weighty Latin opus, *Commentaria allegorica, et moralia de Christo figurato in Veteris Testamento* (1632).

The spiritual significance of the story of Jacob, developed by Ambrose and elaborated upon by Sales and Baeza, is fundamental to the principal conceit herein proposed for *The Life of Jacob:* the triumph of the faith. Murillo's manipulation of this familiar allegory is documented in chapters 6 and 7 of this study, with chapter 6 defining the function of the patriarch and chapter 7 explaining the spiritual significance of Rachel. In chapter 8 the argument is speculative. In it is documented the successful life of the Marquis of Villamanrique, the series's probable patron, to elaborate a theory that Murillo's sophisticated Old Testament cycle contains a second, erudite conceit celebrating the personal ambitions of its late seventeenth-century sponsor. This final argument, which closes part II, unfortunately cannot be proved until documentary evidence surfaces to establish the Marquis's enlightened sponsorship of *The Life of Jacob.*[20]

6

Jacob as a Figure for the Redeemer

urillo highlights Jacob's exploits in three of the monumental canvases comprising *The Life of Jacob*. By stressing the patriarch's elect status and virtuous determination in *The Blessing of Jacob*, *The Dream of the Ladder* and *The Laying of the Peeled Rods*, the artist generates parallels between Jacob and Christ. Within the spiritual conceit, Murillo's opening episode, *The Blessing*, expresses God's transference of His favor from the Hebrew people, prefigured in Esau, to the Christians, represented by Jacob. Interpreted symbolically, *The Blessing* is the heralding of the coming of Christ. The cycle's only night scene, *The Dream of the Ladder*, offers a parable of the mysterious nature of the Redeemer, both man and God. And Murillo's luminous fourth composition, *The Laying of the Peeled Rods*, recalls Christ's public life through a comparison of the Old Testament shepherd, Jacob, to the Good Shepherd, Jesus Christ.

Murillo's first painting (fig. 29) illustrates Isaac's mistaken bestowal of the benediction upon the younger of his twin sons, Jacob (Gen. 27:18–29). According to Genesis, when the elderly and blind Isaac was ready to bless his first-born, Esau, he sent him out to hunt game that he might feast prior to performing the ritual act. But the patriarch's determined wife, Rebecca, who preferred Jacob to his brother, overheard this directive and schemed to benefit her younger son. She hastily roasted a kid, covered Jacob's arms in animal skins that he might better resemble the hairier Esau, and sent him in to deceive his father.

This scriptural deception was popular with Christian artists throughout the ages. Illustrations of the blessing appeared as early as the fourth century in the catacombs of the *Via Latina* (Rome), occurred occasionally during the Renaissance, when it forms the principal scene of the first tapestry woven by Kempeneer, and appeared frequently during the Baroque period.[1] Murillo's composition follows a 1612 canvas produced by the Toledan artist Pedro Orrente.[2] In both Spanish paintings the blessing is staged in Isaac's canopied bedchamber located in the right-hand side of the canvas, and in both, the patriarch's fraudulent offspring is encouraged by Rebecca, whose extended arm protectively encircles her kneeling son. Murillo's picturesque still-life items of a metal cauldron and ceramic jar, which he featured in his composition's center foreground, find their match in the metal pots strewn before Isaac's home in Orrente's painting. Additionally, in both Spanish pictures the exterior wall of Isaac's house recedes at a sharp angle into the left-hand side of the canvas. In this area, otherwise reserved for landscape, a water-carrying woman is seen from the back, and far in the distance is the unlucky figure of Esau, accompanied by his hunting dogs.

Ambrose interpreted the significance of the blessing in the fourth century. According to this ancient theologian, the misfortune of the elder brother, Esau, and the corresponding luck of the younger, Jacob, symbolizes God's larger, mysterious plan. Ambrose invoked God's prophecy to Rebecca (Gen. 25:23), delivered as her twin sons struggled in the womb: "Two nations are in your womb, and the two peoples, born of you, shall be divided; the one shall be stronger than the other, the elder shall serve the younger." He declared that these verses signified that Esau was a figure for the Hebrew people, originally God's chosen, and that Jacob was to represent the Christians who, on account of the sins of the Jews, supplanted them in God's favor.[3]

The brothers' varying merits justified Ambrose's allegory. Citing Gen. 25:27, which describes Jacob as "a quiet man, dwelling in tents" and his sibling Esau as a "skillful hunter, a man of the fields," Ambrose argued for Jacob's greater virtues. He explained that, whereas Jacob furnished food of a gentle manner acquired at home, "and a feast of tenderness, mildness and affection," his indifferent brother, Esau, gathered noxious game by the rough ways of hunting. For Ambrose,

this disparity signified that "the kingdom was predestined to be bestowed on the Church rather than on the synagogue, but had secretly entered the synagogue so that sin might abound and, when sin had abounded, that grace might also abound."[4] Ambrose's mystery is suggested in Murillo's painting by the faraway figure of Esau, who returns from the hunt just as his sightless father raises one hand and unwittingly blesses his younger brother. A pictorial metaphor for Jacob's and Esau's antithetical fortunes may be provided in the painting by the two doves roosting on a perch that extends from Isaac's house. These creatures recall the Spanish proverb, *hijo de gallina blanca* (son of a white hen), catalogued by the Sevillian humanist, Juan de Mal Lara (1527–1571), in his compendium of popular Spanish refrains, *La philosophía vulgar* (Popular philosophy, 1568). Mal Lara interprets the proverb as referring to a child born with good fortune and many blessings. Its opposite, he declares, is the son of a black bird, an analogy Mal Lara credits to the ancients who understood the black bird as a symbol of evil.[5] In the painting, the fortunate white bird stands firmly erect at the opening of the dove cote, while the black pigeon, positioned before it, lowers its head in obedience. Together they aptly express God's prophecy to Rebecca (Gen. 25:23) regarding Jacob and Esau: "The elder shall serve the younger."

Jacob's and Esau's mother, Rebecca, was instrumental in fulfilling God's prophecy. According to Ambrose, when she assisted Jacob by giving him the garments of Esau and covering his arms and neck in animal skins, she abetted a holy endeavor:

> Jacob received his brother's clothing . . . because he was conspicuous in the merit of his faith. Rebecca presented this clothing as a symbol of the Church; she gave to the younger son the clothing of the Old Testament . . . and she gave it to the Christian people, who would know how to use the garment they had received, since the Jewish people kept it without using it and did not know its proper adornments.

For Ambrose, Rebecca did not so much prefer Jacob to his brother; rather, she offered him to the Lord because she knew that Jacob could protect His gift.[6]

Rebecca's crucial role in the Christian significance of the blessing is suggested in Murillo's painting. As the dark-haired Jacob kneels before Isaac, his forearms covered in animal skin, Rebecca stands beside him, encouraging him in his mission; her left arm gently encircles Jacob, and her open right hand demonstrates her frankness. Her appearance bespeaks holiness; her motions are graceful and poised, her expression one of calm assurance as she awaits God's blessing which, given to her younger son, promises the coming of a redeemer for the Christian people.

Murillo's first episode of the blessing is followed by *The Dream of the Ladder* (fig. 30), which declares the mysterious essence of the Redeemer. According to Genesis 28:10–17, Jacob fled Canaan to avoid Esau's wrath over the theft of his birthright. Traveling toward the land of Haran, where his maternal uncle Laban lived, the patriarch became weary and lay down to rest. Thereupon he experienced an extraordinary dream in which he saw a ladder that reached to heaven with ascending and descending angels. Above it stood the Lord who spoke to him and promised him the land upon which he lay, the multiplication of his descendants who would come to be "like the dust of the earth," and His eternal blessing upon his posterity. God also pledged to be with Jacob and keep him until He returned him to the land where he now lay.

Murillo's interpretation of the dream presents Jacob asleep in the center foreground of a night landscape. Resting beside the recumbent patriarch are his hat, staff, and drinking vessel. A colossal ladder rising from the ground behind Jacob accommodates six adolescent angels, three ascending its rungs and three descending. As the largest arriving spirit looks benevolently towards the patriarch and extends a hand in a gesture of explanation, its departing companion, with one foot on the ladder, begins the ascent to heaven.

With Christian artists, the dream of the ladder was far and away the most popular event represented by *The Life of Jacob*. This overwhelming interest is probably accounted for by the dream's parallels to the story of Christ. Of five scenes illustrated by Murillo, only Jacob's dream is included in two important typological publications of the Middle Ages, the *Biblia Pauperum* and the *Speculum Humanae Salvationis*.[7]

The dream is also represented during the Renaissance, when it appears in Raphael's frescoes in the Vatican loggia and in Kempeneer's second tapestry. The episode's landscape setting insured its popularity in the seventeenth century when Jacob's vision is illustrated in paintings and prints by numerous Spanish, Dutch, and Italian artists.[8]

According to Christian theologians, Jacob's prodigious dream prophesied the mysterious nature of the Redeemer as both man and God. For Ambrose, the vision meant that Jacob "foresaw Christ on earth; the band of angels was descending to Christ and ascending to him, so as to render service to their rightful master."[9] Villegas explained in the sixteenth century that Jacob's ladder represents the humility of Christ joined to His divinity.[10] His analogy was elaborated upon by the Jesuit priest Melchior Prieto, who identified the dream as an allegory of the Eucharist in his 1622 book, *Psalmodia Eucharística*. Prieto compared the descending angels of Jacob's vision—an experience that, like all mysteries of the faith, cannot be seen but must be believed— to "those thousands of angels that descend to adore the host during the mass."[11]

The Christian allegory contained by the dream is affirmed in the series by Murillo's concrete representation of an invisible experience. Murillo deviated from a format followed by most Baroque artists when he modelled Jacob's ethereal visitors as solidly as the patriarch himself. His interpretation is quite different from that of Jusepe de Ribera (1591–1652), in whose 1639 canvas (fig. 36) God's tiny messengers are barely discernable in the brilliant light descending from heaven. Murillo's unusual, palpable version of the dream conforms instead to the interpretations of Golden Age playwrights Luis Vélez de Guevara (1578–1645) and Lope de Vega. Directions for Vélez de Guevara's 1616 script *Comedia famosa de la hermosura de Raquel* (Famous comedy of Rachel's loveliness), and those for Lope de Vega's one-act *auto sacramental, Obras son amores* (Deeds express love), written in 1620, indicate that Jacob's vision was produced with a combination of painted scenery, props, and actors. While Vélez de Guevara's play requires that Jacob "lie down and sleep, whereupon a ladder appears reaching to the sky, upon which some angels ascend and descend and God the Father at the top," Lope's calls for "a curtain to open to the sound of

36. Jusepe de Ribera, *The Dream of Jacob,* 1639. Museo del Prado, Madrid.

music, a sky is seen, with a ladder reaching to the earth, with some angels upon it, and at the summit a painting, with a gilt frame, and a silver curtain, behind which is the King of Heaven."[12]

The staging of the dream as a visible experience depends upon the playwrights' acceptance of the Redeemer as both God and man. In *Obras son amores,* the patriarch's vision is one of the revelations that Amor, or Divine Love, recalls to Human Nature to remind her of God's promise that His divinity will descend to earth to marry her. As the curtain rises upon the dream, Amor explains

> Just as you saw,
> Human Nature,
> this ladder, at whose zenith
> God omnipotent assists,
> touch both extremes
> and stretch from heaven to earth,

you will be able to touch heaven
and God the earth.[13]

Lope's interpretation is suggestive of Murillo's concrete representation of the patriarch's vision, symbolic of Christ's dual nature as both God and man.

Murillo's fourth painting, *The Laying of the Peeled Rods* (fig. 33), extends the Christ/Jacob analogy by paralleling the Old Testament shepherd Jacob to Christ, the Good Shepherd. According to Genesis, after Jacob awoke from his marvelous dream and erected an altar of thanksgiving, he continued his journey to Haran, where Laban lived. For his uncle, he labored fourteen years, the first seven to earn the hand of his beautiful cousin, Rachel. After the unscrupulous Laban substituted Rachel's less-attractive sister, Leah, on the wedding night, Jacob labored the second seven years so that he might finally wed Rachel. After Leah had borne the patriarch seven children and Rachel had given birth to Joseph, Jacob asked his uncle to allow him to return with his family to his homeland of Canaan. Rather than demand wages for his years of service, he arranged a deal with Laban whereby he would continue to tend his flocks but in the future, keep any lambs born speckled or spotted, returning only those born with snow-white fleece. The crafty Laban thereupon removed all the mottled and black sheep from the herd and turned these over to his sons to pasture. But Jacob resourcefully shaved green branches from the poplar, plane, and almond trees in streaks to expose the white of the bark and set the rods before his charges in the watering troughs. With the striped examples before them, the white sheep bred spotted and speckled lambs, and Jacob became a rich man.

Murillo's version of the scriptural event represents the patriarch carefully placing another long, peeled rod into the winding stream where the flock of white sheep drink. Beside Jacob on the river bank rests the knife he used to score the rods. In the middle ground are two shepherds guiding their flocks and the proof that Jacob's ruse will bear fruit, two copulating sheep. The patriarch's powerfully built figure is framed in the composition by an enormous boulder from the apex of which sprout two leafy branches from two tree stumps. Behind this

rock stretches a fantastic landscape that includes a ramshackle bridge and a waterfall on the right, a decrepit shepherd's cottage on the left, and, in the distance, haze-shrouded mountains.

Unlike the first two scenes in Murillo's cycle, the laying of the peeled rods was relatively unpopular with all but Spanish artists of the seventeenth century. The story appeared first during the Renaissance in illustrated Bibles and in the fourth tapestry woven by Kempeneer. It also appears in seventeenth-century paintings by the Italians, Antonio Zanchi, and Salvator Rosa. With Spanish Baroque painters it enjoyed exceptional popularity and was illustrated twice by Ribera (El Escorial and The National Gallery, London), numerous times by Orrente (fig. 37 and Colegio de San Antón, Madrid), and once each by the Sevillians, Francisco Antolinez (Museo Ponce, Puerto Rico), and Murillo.

Ambrose interpreted the event as a mystical allegory of Christ's mission on earth. According to this theologian, Jacob was the master who, in his ministry of preaching the gospel, gathered together a flock that was resplendent in the brilliance of its many signal virtues, the Old Testament shepherd becoming a figure for the Good Shepherd and his flock for the Christian faithful. By attending the teacher's example

> those [sheep] who felt the desire for the mysteries of the most blessed Trinity that were prefigured there could engender offspring that were not at all discolored, by conceiving them in a devout mind. Good were the sheep that produced offspring that were good works and that were not degenerate in holy faith . . . as Scripture says, Jacob became rich by such means and reared a very good flock for Christ.[14]

The vigorous, striding figure of Jacob in Murillo's painting suggests Ambrose's mystical Christ/Jacob analogy. Unlike Orrente's version of the event (fig. 37), which represents the patriarch abstractedly arranging the rods in a watering trough, Murillo's resolute hero moves purposefully into the water, actively encouraging the white sheep forward. Whereas Ribera's two paintings describe a placid Jacob patiently awaiting the fruits of his labors, Murillo's virile shepherd, with his sleeves pushed energetically up about his elbows, effectively guides his flock with the careful placement of the long, striped rods.

37. Pedro Orrente, *Jacob Conjuring Laban's Sheep,* ca. 1612–1622. North Carolina Museum of Art, Raleigh; purchased with funds from the State of North Carolina.

Further support for the identification of Jacob's divine alter ego "good shepherd" is provided by a sixteenth-century print of the good shepherd at the Last Judgment (fig. 38). This print designed by the Antwerp engraver Pieter Nagel (ca. 1569–1604) is similar in its composition to Murillo's painting.[15] In the foreground, Nagel represents the muscular figure of the good shepherd framed by a large boulder. Like Jacob in Murillo's painting, this character steps forward with his right foot while turning his head towards the sheep at his right to supervise their movements. The long staff clutched by the good shepherd resembles the three rods held by Jacob. Nagel's print illustrates the following verses of Matthew (25:31–41):

> When the Son of man comes in his glory . . . he will place the sheep at his right hand, but the goats at the left. Then the king

38. Pieter Nagel, *The Good Shepherd at the Last Judgment*, late sixteenth century. Biblioteca del Monasterio de San Lorenzo de El Escorial (fotografía cedida y autorizada por el Patrimonio Nacional).

> will say to those at his right hand, "Come O blessed of my Father, inherit the kingdom prepared for you from the foundation of the world." Then he will say to those at his left hand, "Depart from me, you cursed, into the eternal fire prepared for the devil and his angels."

In the print, the wicked goats appear to the left of the good shepherd, their dire fate pictured in the background. Perhaps the same lot awaits the sheep represented in the middle ground of Murillo's canvas, animals led off and away from the patriarch, the "Good Shepherd," by characters who presumably represent Laban's sons.

Jacob's divine alter ego finds a suitable background in the remarkable scenery of *The Laying of the Peeled Rods*. The verdant meadows,

39. Ignacio Iriarte, *Landscape with Sheep and Goats*, 1665. Museo del Prado, Madrid.

crystal-clear river and high mountains, which suggest an earthly Jerusalem, are subdivided by color gradations: darker ochres and greens predominating in the foreground; softer, more diaphanous greens in the middle ground; and pastel blues and pinks in the background. The painting's fanciful color sequence recalls sixteenth-century Alpine landscapes by the Flemings Joos de Momper and Paulus Bril, whose canvases were popular with Spanish collectors. In its disposition of forms the work resembles a signed 1665 landscape by the Sevillian Ignacio Iriarte.[16] As in *The Laying of the Peeled Rods*, Iriarte's *Landscape with Sheep and Goats* (fig. 39) presents a rocky formation in the center foreground from which spring two leafy trees, cliffs in the middle ground, and imposing mountains in the distance. The paintings' striking similarities recall Palomino's tale of Murillo's and Iriarte's dispute over who should execute his portion of the Villamanrique paintings first. Given the artists' competitive spirits, one might suggest that with his most ambitious scenery of the cycle Murillo hoped to rival the landscapes of Iriarte, a specialist in the genre.[17]

But surely more important in fashioning the fairytale-like scenery of *The Laying of the Peeled Rods* was the creation of a landscape sufficiently

symbolic to contain the divine figure of the Good Shepherd. Murillo's intent is clarified by his landscape's similarity to one described by Lope de Vega in his *auto sacramental El pastor lobo y cabaña celestial* (The wolf-shepherd and the celestial flock). Lope's early seventeenth-century script is based upon Christ's familiar parable of the good shepherd and the lost sheep (Luke 15:3–6). Lope's poetic verses describe a verdant setting with a crystal-clear river, cypress trees, rich green meadows and mountains. The playwright identifies the dewy, early morning landscape as the earthly Jerusalem, the river at which the flock of white sheep drink as the Jordan, and the mountain in the distance as Mount Zion. After the good shepherd rescues one of his charges from the evil wolf (*El Lobo*), he offers to remove her to pastures filled with light where there are waters that give grace and perfection. *El Lobo* is informed that *El Pastor* (the Good Shepherd) has taken his former victim to a green meadow past where the Jordan flows, washed her sins away, and escorted her up to Mount Zion.[18]

Murillo seems to delineate a similar route in his painting. As Jacob's flock advances out from behind the dramatic boulder of the foreground, the patriarch, with his striped rods, invites his charges into the crystalline stream before them. The master's swivelling pose, which echoes the herd's circular trajectory, might predict the animals' future movements. From their present position, deployed along the grassy riverbank, the sheep could advance into the water and around the boulder to arrive, eventually, at the sunlit landscape described on the right. There the master might gather his purified flock to guide it across the rickety bridge towards the luminous mountains beyond; these fabulous rocks, as in Lope's play, presumably symbolize Mount Zion and the heavenly Jerusalem.

Jacob assumes the role of the good shepherd after receiving God's blessing and acknowledging his nature as both God and man. Truly, Murillo portrays Jacob as one capable of leading his bride, the church, in a victory over heresy.

7

An Allegory of the Faith
Christ and the Church Victorious
over Heresy

acob, the undisputed hero of Murillo's epic cycle, is joined in two of the five canvases by his beautiful Old Testament cousin Rachel. The painter highlights Jacob's passion for Rachel which, for Christian theologians, signified Christ's passion for His bride, the church. Murillo's vanished third painting, *The Meeting of Jacob and Rachel*, illustrated the scriptural couple's encounter at the well in Haran, and the fifth canvas, *Laban Searching for his Stolen Household Gods*, represents the pair accused by Rachel's choleric father, Laban. Jacob's and Rachel's combined appearances in Murillo's two canvases coordinate with the cycle's unifying conceit. Their romantic meeting at the well symbolizes the mystical marriage of Christ and the church, and their fastness before Laban's search for his stolen gods represents the triumph of divine union over heresy.

Christ's passion for His bride, the church, was mirrored, according to theologians, by Jacob's enduring love for Rachel. Smitten by her charms from the moment he arrived in Haran and removed the stone from the well that she might water Laban's sheep, Jacob always desired her more than his first wife, Rachel's watery-eyed sister, Leah. Indeed, he loved even better Rachel's late-coming children, Joseph and Benjamin. Although Leah bore the patriarch six sons and a daughter before her sister conceived, it was Rachel's first born, Joseph, whom

Jacob favored above all the rest. Later singling him out with the legendary coat of many colors, Jacob unwittingly sealed Joseph's undesired, but subsequently marvelous, fate.

Rachel's long-awaited conception of Joseph who, for the curious events in his biography stood as the most accepted Old Testament figure for Christ, converted the beautiful scriptural mother into a perfect foil for the Virgin Mary. Rachel's symbolic relationship to Mary is important to this study given that in Christian theology, Mary is the church personified. Although other Old Testament matrons, particularly Esther, Judith, and Deborah, are more commonly associated with Mary, examples of Rachel as a figure for the Virgin abound. In seventeenth-century Spanish art, she is paired to Mary by Juan de Herrera Barnuevo (1619–1671) in his Chapel of Our Lady of Guadalupe (1653; Convent of the Descalzas Reales, Madrid), and by Palomino in his frescoes for Valencia's Church of San Juan del Mercado (1699).[1] Palomino explained Rachel's significance as follows: "beautiful Rachel . . . represents the Virgin Mary, from whose sacred, fecund, virginal womb came the Redeemer of all mankind: just as from Rachel was born the Patriarch, Joseph, who by so many names is a figure for Christ, our Lord."[2]

In the curious courtship endured by Jacob and Rachel, Ambrose defined a portentous allegory: Rachel's elder sister, Leah, represented the synagogue to whom Christ was initially joined, but which He later rejected in favor of His second and much lovelier bride, the church.

> It is the Lord Jesus Himself who was prefigured in Jacob, a man of two marriages, that is, one who shares both in the law and in grace. He admired the virgin Rachel first; she was predetermined to marriage with him and he loved her with devoted affection. But Leah, like the law, entered in secretly and took him by surprise, and her eyes were somewhat weak, like the synagogue, that could not see Christ from blindness of spirit.

For Ambrose, Jacob's desire for the beautiful Rachel over and beyond his first marriage prophesied that God's preference would be the church.[3]

Murillo introduced us to Rachel in his series's lost third painting,

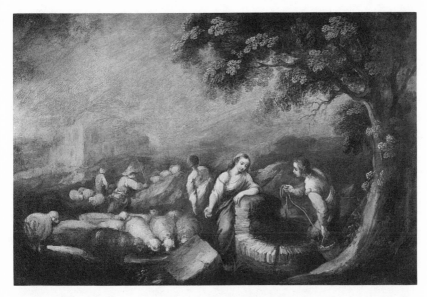

40. Francisco Antolinez y Sarabia, *Jacob and Rachel at the Well,* late seventeenth century. Samuel H. Kress Collection, El Paso Museum of Art.

The Meeting of Jacob and Rachel. This mysterious canvas, whose title is recorded in a sale catalogue of 1817, represented a subject rare in art before the Baroque period.[4] A depiction of the meeting of Jacob and Rachel decorates a fourth-century stone sarcophagus (Museum of San Callisto, Rome) and is illustrated in Raphael's Renaissance frescoes in the Vatican loggia and Kempeneer's third tapestry. Seventeenth-century painters took up the lovers' meeting because it catered to their interest in pastoral romances. Numerous Dutch and Italian painters illustrated the episode, as did the Spaniards Orrente (private collection, Valencia, and Escuela Normal, Madrid), Juan de Zamora (Archbishop's Palace, Seville) and Francisco Antolinez y Sarabia (El Paso Art Museum).

Perhaps Murillo's lost composition approximated a loosely painted picture by his Sevillian follower, Antolinez (d. 1700; fig. 40). Antolinez, who specialized in small-scale canvases illustrating Old Testament stories, painted in a style similar enough to Murillo's to have con-

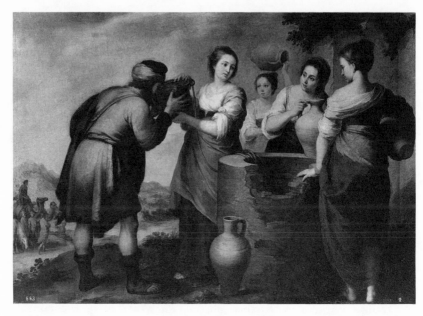

41. Bartolomé Esteban Murillo, *Rebecca and Eliezer,* 1655. Museo del Prado, Madrid.

fused historians. His canvas, *Jacob and Rachel at the Well,* is one of a set illustrating the patriarch's life. It represents Jacob drawing water for Rachel's thirsty sheep. A colossal shade tree frames the enamored patriarch, who gazes longingly at his graceful cousin Rachel posed against the mossy periphery of the well.[5]

Following the narrative in Genesis, Murillo's painting, like Antolinez's, must have anchored the principal characters of Jacob and Rachel to a well. This font may have resembled the large, circular well represented in Murillo's *Rebecca and Eliezer* (fig. 41), a canvas dated just prior (1655) to *The Life of Jacob* and illustrating the reception of Isaac's servant, Eliezer, by Jacob's mother, Rebecca. The well in Haran is crucial to the development of the mystical allegory outlined for *The Life of Jacob:* it represents the baptismal font through whose mysterious, cleansing waters the church weds its bridegroom, Jesus Christ. As early as the fourth century, Ambrose had determined that "wells are fountains of faith and devotion . . . on this account Jacob found

his wife Rachel by the well," while in the seventeenth century St. François de Sales explained that both Rebecca and Rachel met their illustrious mates beside water because "the church must wed Christ in the waters of Baptism."[6]

The mystical marriage of Christ and the church was a popular subject upon the Spanish stage, where it often assumed the form of a pastoral romance. In Lope de Vega's early seventeenth-century *auto sacramental Del pan y del palo* (Of the bread and the wood), based upon The parable of the sower and the tares, Christ is represented by the character *Lord of the Fields,* and the church is personified by *The Bride.*[7] In Calderón de la Barca's later (1658) script, *Primero y segundo Isaac,* based upon the meeting of Jacob's parents, Isaac is compared to Christ and Rebecca to the church. The scene in which Rebecca draws water from the well for Eliezer, an event Calderón compares to the Annunciation to the Virgin, is described by Rebecca:

> The water is . . .
> he in whom Grace is explained
> (for in water one day
> it may be distributed)
> and reach not only you, but
> all of mankind; summon
> your companions, that they may drink;
> and so that you may see that my mercy
> extends not only to all
> of Human Nature,
> but even unto the universal.[8]

Calderón's interpretation of the divine union as a pastoral, Old Testament romance accounts for Murillo's inclusion in *The Life of Jacob* of the romantic episode of *The Meeting.*

The divine union triumphs in Murillo's fifth and final painting, *Laban Searching for his Stolen Household Gods* (fig. 32). According to Genesis 30, after Jacob had outwitted Laban with the peeled rods and become a rich man, his father-in-law ceased to look upon him with favor. One day, while Laban was away shearing sheep, the patriarch gathered his livestock and family and fled across the Euphrates. In-

formed of the exodus three days later, Laban enlisted his kinsmen and pursued Jacob, overtaking him where he had encamped in the hill country of Gilead. There he berated him for abducting his daughters and grandchildren and accused him of stealing his household gods. Unaware that Rachel had pilfered these pagan idols, Jacob declared his innocence and urged Laban to search their belongings, promising him that should he find the desired objects the guilty party would be executed. But when Laban entered the tent of his younger daughter Rachel, he found her seated atop the camel's saddle under which she had cleverly concealed the idols and she informed her father that she could not rise as she was indisposed with "the way of women."

Spanish painters rarely represented Laban's fruitless search. This unusual scriptural episode, which appears in a seventh-century miniature in the *Ashburnham Pentateuch,* a Renaissance tapestry by Kempeneer and seventeenth-century paintings by Dutch, French, and Italian masters, was illustrated only twice in Spain, by Orrente and Murillo.[9] Orrente's version of the event (fig. 34), for many years mistitled *The Journey of the Family of Lot,* surely inspired Murillo's canvas.[10] Represented in the foregrounds of both Spanish compositions is the turbaned figure of Laban, angrily demanding the idols from his distraught son-in-law. Rachel, the silent culprit in the misunderstanding, sits firmly atop her camel's saddle. Laban's armed men, posed astride camels in the left foreground of Orrente's composition, are present in the right middle ground of Murillo's painting. Also significant is that both artists stage the event before a magnificent landscape vista replete with human and animal life. While sheep, horses, camels, and a lonely dog vie for space, in the backgrounds of the paintings anonymous characters tend a large cauldron over an open fire.

Approaching Rachel's tent from the left in Murillo's painting is a supporting cast of women and children. Within the divine allegory, they function allegorically as a buttress to the Christian faith. The buxom ladies, who probably correspond to Jacob's other wife, Leah, and her daughter, Dinah, recall the theological virtues of Hope and Charity, commonly personified in Christian art as full-bosomed young women. Murillo, who celebrated the virtue of Charity in his paint-

ings *St. Thomas of Villanueva Distributing Alms* (ca. 1668; Museo de Bellas Artes, Seville) and *St. Elizabeth of Hungary Caring for the Sick* (ca. 1672; Church of La Caridad, Seville) probably intended for Charity to be personified by the figure at the far left, who is holding an infant. In Christian art Charity is commonly represented with a child in her arms.[11] The woman's companion, who encourages forward two young boys, can be correlated to Hope. The pair, Hope and Charity, becomes a trio with the addition of Rachel, already established as a figure for the church, or Faith.

The innocent children who accompany the women of Murillo's painting represent the promise of salvation through the doctrine of the church. The dramatic contrast they supply to the irate figure of Laban implies a veiled reference to Christ's famous words, which are recorded in the Gospel of Matthew (18:3-4): "Truly, I say to you, unless you turn and become like children, you will never enter the kingdom of heaven." Heedless of the Saviour's warning, the proud and angry Laban is that man who will never attain the promised land.

Ambrose gave a flattering interpretation of the scriptural event that triggered Laban's anger—Rachel's peculiar theft of his pagan idols. According to the theologian, in keeping the golden gods, Rachel was acting as the personification of the militant church that righteously banishes idolatry: "holy Rachel—that is, the church, or prudence— hid the idols, because the church does not know representations and figures of idols that are totally devoid of reality, but she knows the real existence of the Trinity. Indeed, she has destroyed darkness and revealed the splendor of glory."[12]

Murillo's canvas echoes the courageous role assigned to Rachel by Ambrose. Seated calmly atop her camel's saddle, the beautiful matron of the painting supplies her beleaguered mate a sure emotional bulwark. Unlike the interpretations of other Baroque painters, including Orrente in whose Prado composition Rachel is the recipient of Laban's rude address, and the Dutchman Jan Bijlert (1603-1671) in whose version (fig. 42) Rachel engages Laban in angry dialogue, Murillo's matron assumes a passive, even a stoic role. With her head tilted gracefully towards her husband, she seems to give visual expression to the

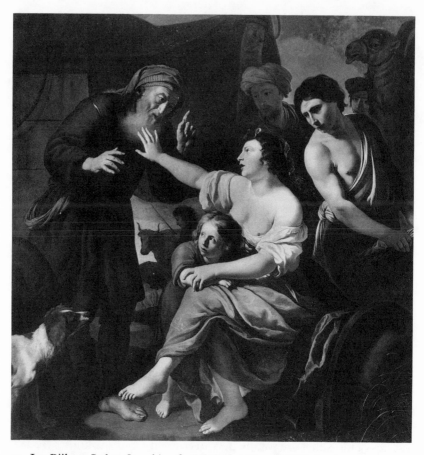

42. Jan Bijlert, *Laban Searching for His Stolen Household Gods,* ca. 1630.
Museum Boymans-van Beuningen, Rotterdam.

words that *The Bride*-personification of the church in Lope de Vega's
early seventeenth-century *auto sacramental La siega* (The harvest)—
says to *The Bridegroom,* figure for Christ:

> I will be such a firm rock,
> that nothing which might presume
> will succeed in budging me,
> whether it be temple on earth
> or ship on the sea.[13]

The immobile Rachel of Murillo's painting likewise remains unmoved by the aggressive search by her angry father Laban.

Ambrose vehemently denounced Laban's unjust treatment of his son-in-law, who had generously provided him with fourteen years of service. In his exegesis, he compared the idolater to the quintessence of evil, the devil:

> Laban, whose name means "he that has been purified"—and even Satan transfigures himself into an angel of light—came to Jacob and began to demand his possessions from him. Jacob answered him, "Identify whatever of yours I may have," that is, "I have nothing of yours. See if you recognize any of your vices and crimes. I have not carried off with me any of your deceits and I have no share in your guile; all that is yours I have shunned as a contagion." Laban searched and found nothing that was his. How happy is the man in whom . . . the devil has come upon nothing that he would recognize as his own. . . . Christ supplied the model of it when He said in the Gospel, "The prince of this world will come and in me he will find nothing."[14]

In *Laban Searching for his Stolen Household Gods,* Murillo updates the timeless evil of the devil into the seventeenth-century abomination of heresy. Following a format conceived by Villegas in his *Flos Sanctorum* and detailed in chapter 5 of this study, Jacob, in Murillo's final painting, defends the Christian faith not against the intangible figure of Satan, but against the real and present threat of heresy. While in the painting Laban's malicious nature is suggested by his harsh physical appearance—sunken cheeks, fiery eyes, and ragged beard—his eastern identity is indicated by his clothes. In contrast to the simple shepherd's garb of Jacob, Laban wears the exotic accessories of a turban and an ornamented dagger. While in most of Christian Europe the presence of turbans and other curious gear identified a character as Hebrew, for Murillo's countrymen, who recalled Spain's many centuries of Muslim domination, that orientalized costume would have connoted the odious north-African infidel and the heresy of Islam.[15]

Two other enemies of the Counter-Reformation may be identified with Laban's men, who pose in the middle ground of Murillo's composi-

43. Bartolomé Esteban Murillo, *Laban Searching for His Stolen Household Gods in Rachel's Tent* (detail), ca. 1660–1670. The Cleveland Museum of Art, gift of the John Huntington Art and Polytechnic Trust, 65.469.

tion awaiting their leader's directives (fig. 43). The costume of the corpulent soldier with his back to the viewer seems to allude to northern-European Protestantism. Wearing a belted jerkin, small helmet, and high leather boots, this sway-backed figure does not belong among Murillo's repertoire of types. A Dutch or Flemish composition may have inspired this character who closely resembles a *naar het leven* sketch of an armed peasant attributed to the Flemish-born painter Roelant Savery (1576–1639; fig. 44). The unkempt figure who addresses the soldier and wears a floppy hat and a ragged vest constructed of animal skins might be identified with atheism. The pelts worn by this man and by the soldier standing at the far left of the group recall the costume required of the character, *Atheism*, in Calderón de la Barca's allegorical script, *A Dios por razón de estado* (God's for reason of state).

44. Roelant Savery, *Armed Peasant,* early seventeenth century. KdZ 733. Kupferstichkabinett, Staatliche Museen Preussischer Kulturbesitz, Berlin.

In this play, circa 1649, the dress assigned *Atheism* is intended to suggest the character's inward brutishness.[16]

Christ's and the church's vanquishing of heresy was a well-recognized theme in the Spanish dramatic arts as witnessed by Calderón's scripts, *A Dios por razón de estado, La cura y la enfermedad* (The cure and the sickness), *La cena del rey Baltasar* (King Balthasar's feast) and *El gran mercado del mundo* (The world's great market).[17] In Lope de Vega's cited *La Siega, The Bride* and *The Bridegroom* are victorious over Hebrewism, Luther's Protestant heresy, and Idolatry, the latter identified as the idol worshipers of Africa and Asia. When the evil characters of Pride and Envy sow chaff in *The Bridegroom*'s fields, heresy grows

and each of its misguided manifestations introduces itself as it sprouts. As Hebrewism recalls its illustrious history, the character of Ignorance comments "For him I am most aggrieved / since, as he is so rebellious, / so obstinate and so blind, / at his back he still keeps Christ."[18]

Lope's description of the Jews as rebellious and stubborn suggests that Hebrewism lurks in Murillo's final painting disguised as Laban's camels. This exotic beast, which is associated with the ancient world, is given a significant interpretation in Horozco y Covarrubias's *Emblemas morales* (fig. 45). The author explains his illustration of a camel agitating the waters of a stream with its hoof as representative of those people who try one's patience with too much questioning, who consider argument a science, and who look for reasons to counteract reason itself. For the Counter-Reformation mind, such people were the Jews who, privileged to hear the prophecies, to witness the miracles, and to experience Christ on earth, still refused to believe and, like the camel, looked for reasons to counteract reason itself.[19]

Therefore, interpreted symbolically *Laban Searching for his Stolen Household Gods* represents the rout of the combined forces of evil—Islam, Protestantism, atheism, and Hebrewism—by the champions of the Faith: Jacob and Rachel, Christ and His church. The victory of this passionate duo is expressed in verses spoken by the character of *Divine Love*, a foil for Christ, in Lope de Vega's allegorical script, *Las aventuras del hombre*, (The adventures of man), which is based upon the union of divine love and the soul. Like Jacob indicating the steadfast Rachel in Murillo's painting, *Divine Love* looks to his church and says

This is the divine ship
of the militant church . . .
This is the promise that saves.
Sure through the perils
of the infernal gates,
she will step with the wind in her sails
over the prideful tempests.
Heresy and Cruelty,
it makes no difference if they oppose her.[20]

45. Emblem 13 in Juan de Horozco y Covarrubias's
Emblemas morales, Segovia, 1589, page 121 (photo:
Biblioteca Nacional, Madrid).

8

The Patron's Triumph

mbrose's moral interpretation of the patriarch's story provides a framework in *The Life of Jacob* for an allegory exalting the patron. In his series, Murillo might imply his sponsor's Christian virtue via the exploits of the righteous patriarch to suggest that, like Jacob, he was blessed by God. Such flattery of a patron, while it agrees with the advice of Spain's theoreticians regarding the usefulness to painters of scriptural biography and accords with other depictions of Old Testament personages by Spanish Baroque artists, cannot be proved for *The Life of Jacob*. By its very definition, a personal conceit requires a patron, and the case for the Marquis of Villamanrique's sponsorship of the cycle, while accepted by most scholars, rests upon circumstantial evidence alone. The parallels drawn in this chapter between the successful life of the marquis and the story of the patriarch are not intended to bolster the argument in favor of the marquis as patron although they may in fact accomplish this. Instead, they are included to suggest that Jacob may have been selected as the subject of Murillo's series not only because his story aptly illustrates the allegory of the triumph of the faith, but also because Jacob's exemplary life, which was rewarded by God, suited the aspirations of a patron. How Murillo's paintings may have decorated the patron's home is briefly suggested at the end of this chapter.

In the fourth century, Ambrose defined Jacob as an exemplar of Christian behavior. As has already been noted, when the theologian examined the allegorical significance of the patriarch, he also elaborated a tropological, or moral, meaning. More than a foil for Christ,

Jacob was a model Christian whose every action, even if suspect on the surface, was conceived in accordance with God's will. It was for his courage and devotion, Ambrose reasoned, that God rewarded Jacob with blessings and riches: the benediction by Isaac, the marvelous dream of the ladder, the hand of Rachel in matrimony, and his prosperity waxing in the miraculous multiplication of Laban's flock. Rachel, in turn, was the model spouse, whose prudence and courage were virtues worthy of emulation.[1]

Spain's theoreticians and painters believed the scriptural stories might edify or inspire a patron. Vicente Carducho (ca. 1576–1638), an Italian-born painter at the Spanish court, advised in his theoretical treatise *Diálogos de la pintura* (Dialogues on painting, 1633) that the chambers of a queen could contain "histories of prudent matrons, chaste and valiant, of which the Holy Scriptures give us example to exhort us spiritually and morally."[2] Antonio Palomino seconded the advice, declaring that the rooms should contain "noble, decorous and honest themes" from the lives of the valiant women Esther, Abigail, and Deborah.[3] The painters who frescoed Philip III's Pardo Palace near Madrid early in the seventeenth century with scenes from the lives of Old Testament exemplars hoped to enlighten and inspire their royal sponsor. In the palace's audience hall, Eugenio Caxés (1575–1634) represented the episode of Solomon's judgment, and the virtuous lives of Esther and Joseph were illustrated by Jerónimo de Cabrera (ca. 1550–1618) and Patricio Caxés (d. 1622), respectively, on the ceilings of the queen's chamber and gallery.[4] Commissioned some half-century before *The Life of Jacob* was the anonymous, painted decoration in the principal salon of the Archbishop's Palace in Seville. The illustrated scenes, including biblical stories, images drawn from the Apocrypha, and emblematic conceits, were intended to morally guide the city's bishops and exalt the Catholic church and its delegate in Seville, Fernando Niño de Guevara, who probably devised the program's erudite iconography.[5]

A self-congratulatory message may also be present in *The Life of Jacob* in the form of an allegory exalting the patron. Most scholars identify Murillo's sponsor as Manuel Luis de Guzmán y Zúñiga, the fourth Marquis of Villamanrique, whose extraordinary good fortune

underscores his likeness to the righteous patriarch Jacob. Manuel Luis de Guzmán y Zúñiga was born in Seville in 1627 to the third Marquise of Villamanrique and her consort, Melchor de Guzmán.[6] In accordance with Spain's primogenital inheritance laws, this eldest son of landed nobility inherited the entire family fortune at the passing of his mother. Manuel's lucky future was acknowledged by Seville's archbishop, who baptized him in the Church of Santa María la Blanca on February 14, 1627, and by the Marquis of Velada, Philip IV's influential military commander, who delivered his twenty-three-year-old daughter, Ana, to Manuel in a marriage ceremony held on January 5, 1650 in the Royal Palace in Madrid.[7] The couple was soon blessed with children: Melchor, born in 1651; Antonio, born two years later; Bernardino, born in 1668; and the girls, Constanza and María Andrea.[8]

Enviable futures were arranged by Manuel and Ana for their children; the parents betrothed the eldest, Melchor, to the daughter of the Duke of Medinaceli, Charles II's ambitious first minister; for the older daughter, Constanza, they arranged an excellent match with Antonio de Toledo, scion of Spain's most celebrated noble family, the Dukes of Alba; and the younger sister, María Andrea, wed the very wealthy Duke of Sessa.[9] Earmarked for a diplomatic career, the second son, Antonio, was dispatched to Italy in 1673 into the care of Ana's elder brother Antonio Pedro Dávila, then Viceroy of Naples.[10]

The recent good fortune of Ana's elder, diplomat brother was of special significance to Manuel and Ana. For Antonio, well into middle age and childless, inherited two prestigious titles in quick succession: Marquis of Astorga, acquired from a childless uncle who died in 1659, and Marquis of Velada, assumed at the death of his father in 1666.[11] The powerful Astorga title carried with it the enviable designation of *grande*, the privilege of being treated not as a vassal to the king, but as his cousin.[12] Antonio's three barren marriages implied that the rich Astorga-Velada legacy could only continue through Ana and her offspring. By the decade 1660–1670 and the commissioning of *The Life of Jacob*, it must have seemed clear that one day Manuel, or his eldest son Melchor, would enjoy the combined titles of Marquis of Astorga, Velada, and Villamanrique and all the estates—with their income, palaces and servants—that this legacy entailed. This splendid bequest,

which became Manuel's in 1689, was earlier augmented by the Marquisate of Ayamonte, which had been willed to Manuel's mother by her cousin, the Marquise of Ayamonte, who died in 1662.[13]

Like the prosperous subject of Murillo's cycle, Manuel's temporal blessings were many. His splendid future he could credit in part to an excellent marriage and, given the scant year that separated his birthdate from Ana's, that prosperous union may even have been a love match. Like the scriptural couple's two beloved children, Joseph and Benjamin, Manuel and Ana had two strong sons, Melchor and Antonio. A parallel to Jacob's blessing and Esau's disinheritance is found not in Manuel himself, but in the inverse fortunes of his uncle, Gaspar, and his father, Melchor—first and second sons of the powerful eighth Duke of Medina Sidonia.

Manuel's grandfather, Manuel Alonso Pérez de Guzmán el Bueno, bequeathed the entire Medina-Sidonia legacy to his eldest son Gaspar.[14] This spectacular inheritance—territories that included more than half of the province of Huelva in southwestern Spain, the prestigious title of Captain-General of the Ocean-Sea and Coasts of Andalusia, Lordship of the city of Sanlúcar de Barrameda, as well as membership in the princely Order of the Golden Fleece—became Gaspar's in 1636. Gaspar's younger brother, Melchor, acquired only one title, Marquis of Villamanrique, through marriage. But this distribution, which seems so disproportionate, soon shifted in favor of the second son and his descendants due to Gaspar's erratic behavior.

Capitalizing on the various insurrections besieging the monarchy, in 1641 Gaspar and his cousin, the Marquis of Ayamonte, conceived a plot to acquire for themselves the southern Spanish land mass of Andalusia.[15] With the support of the rebel ruler of Portugal, João IV, who was married to Gaspar's sister, and the promised assistance of Dutch and English troops, they hoped to sever Andalusia from the crown and declare Gaspar its liege. Exposed at the court by the treachery of a former prisoner in Lisbon, the Marquis of Ayamonte was arrested and subsequently beheaded in Segovia in 1648. Gaspar's neck was spared through the intervention of his powerful relative, the Count-Duke of Olivares, Philip IV's first minister. Philip punished Gaspar by levying a heavy fine, confiscating a portion of his land, and

revoking his title of Lord of Sanlúcar de Barrameda. For five long years Manuel's uncle was imprisoned in the fortress of Coca, and for the remainder of his life, he endured exile in the dreary Castilian city of Valladolid. Although his position as Duke of Medina Sidonia was preserved, Gaspar's prestige was shattered, his name besmirched, and the reputation of the family clouded for generations to come.

When the plot was exposed, fourteen-year-old Manuel was living in his uncle's palace.[16] To this impressionable youth, it may have seemed that Gaspar, a traitor to the crown, was receiving the harsh, but just, reward for his prideful action. Son of the virtuous second son who had died just two years earlier, Manuel's slate was clean. In the future he made sure that it remained so.

Rather than seeking political power or military honor in the years that followed, Manuel cultivated an image of pious Christian devotion. First, he acquired membership in Seville's religious brotherhoods, including that of the Holy Sacrament and the prestigious Order of Charity.[17] Second, he assumed a leadership position in the pomp and spectacle that characterized the seventeenth-century Church in Seville. In 1660, Manuel led the procession of nobles for the auto-da-fé staged by the Inquisition, an important one that year since seven accused heretics were burned at the stake.[18] Five years later, during the celebration that opened the refurbished Church of Santa María la Blanca, he led the procession of gentlemen that, with lighted red candles, accompanied the statue of the Immaculate Conception.[19] Indeed, after mid-century, Manuel's name turns up in almost all of the public church displays recorded for Seville: in 1668 he carried the standard in the parade commemorating the beatification of St. Rose of Lima, and the following year he participated in a Palm Sunday procession organized by the impassioned Jesuit proselytizer Tirso González de Santalla.[20]

Manuel's zeal, remarkable even in its own day, suggests that this seventeenth-century Spanish nobleman justified his burgeoning wealth and prestige to his countrymen, his siblings, and his Christian conscience by demonstrating that, as with Jacob, God was rewarding him for his virtue. This self-serving attitude is suggested in *The Life of Jacob* by the exceptionally large boulder framing the patriarch in *The*

46. Emblem for the Marquise of Pescara, in Paolo
Giovio's *Diálogo de las empresas militares y amorosas*, Lyons,
1562, page 103 (photo: Biblioteca Nacional, Madrid).

Laying of the Peeled Rods. Murillo's prominent landscape item, which
figures in other Sevillian canvases of the period, acquires special
significance in Paolo Giovio's emblem book, *Dialogo dell'imprese mili-
tari et amorose*, translated into the Spanish language in 1558 (fig. 46).
Giovio's emblem, created for the Marquise of Pescara, compares the
envy (by certain mean-spirited individuals) of the pious, noble lady to
angry waves buffeting a large, impregnable rock in the sea.[21]

With his exemplary public behaviour, Manuel may have believed
he was providing his fellow Sevillians an excellent model of Christian
comportment. This is deduced from an emblem based upon the lay-
ing of the peeled rods and published twice in the decade of the crea-
tion of *The Life of Jacob*. The image of a flock of sheep looking across
the banks of a stream at a barrier of upright, peeled rods appeared in
Juan de Solórzano Pereyra's *Década de los emblemas* (Ten volumes of
emblems) (fig. 47) and was republished shortly thereafter (1661) in
Andrés Mendo's *Príncipe perfecto y ministros ajustados* (The perfect
prince and the just ministers). The emblem explains the importance

47. Emblem 29 in Juan de Solórzano Pereyra's *Emblemata centum, regio politica,* Valencia, 1658–1660, page 219 (photo: Biblioteca Nacional, Madrid).

to a people of its leader's actions. As Solórzano Pereyra writes: "The Prince is the mirror . . . of his subjects; . . . there is no more efficaceous way to correct, and insure, the good customs of his vassals than with the exemplary life of the said Prince and [other] superiors. . . . Jacob was the prince, the peeled rods his actions, the sub-

jects his sheep, the lambs conceived the thoughts and customs of the people."[22] Solórzano Pereyra's emblem derived from the story of Jacob is exclusive to the two Spanish books. Its publication twice in the period 1658–1661 supports a theory elaborated in this chapter that Murillo's *The Life of Jacob* celebrates the patron's triumph as a model of Christian comportment and a paragon of Catholic virtue.

The argument for divine favor through merit, which enables the patron's triumph, is present in *The Life of Jacob* irrespective of whether one accepts the marquis's sponsorship of the cycle. This celebration of elect status, Jacob's and also perhaps the patron's, surely would have been clarified for the viewer through the careful ordering of the paintings upon the sponsor's walls. How Murillo's canvases may have been distributed in a room is surmised by José García Hidalgo's (ca. 1642–1717) etching of the decorated vestibule of a stately residence. García Hidalgo's print, included in his painters' manual *Principios para estudiar el nobilísimo y real arte de la pintura* (Principles for the study of the very noble and royal art of painting, 1693) (fig. 48), indicates that seventeenth-century Spanish collectors commonly hung larger canvases very high, almost touching the ceiling, and arranged smaller works in a second tier below. This format, which calls for Murillo's oversize paintings to hang near the ceiling, accounts for the Sevillian's placement of his principal figures very near the lower edges of the compositions. His unusual arrangement makes their actions readable even when viewed from a high and seemingly disadvantageous angle.

Also, the distribution of Murillo's canvases determined how a viewer perceived his paintings. Precisely where *The Life of Jacob* hung or when its sponsor exhibited the paintings obviously cannot be known.[23] But the layouts of the individual compositions do provide important clues regarding how a viewer might be expected to approach each canvas. For example, *The Blessing of Jacob,* the series's first composition, is designed for viewing at an oblique angle. This is surmised from the receding angle given Isaac's home as well as the concentration of the action in the painting's right side. Perhaps this canvas was intended for hanging upon a short end wall of a rectangular salon, or other public room. However, the third and fourth works in the series are designed to be seen straight on. These paintings, along with the second,

48. "Interior of a vestibule," in José García Hidalgo's *Principios para estudiar el nobilísimo y real arte de la pintura*, Madrid, 1965, n.p. (photo: Biblioteca Nacional, Madrid).

lost, canvas, may have hung together on a long wall of a room. The series's fifth painting, *Laban Searching for his Stolen Household Gods*, has its principal figures and action concentrated at the left, the opposite of the first canvas, suggesting that it was intended for hanging across from and facing *The Blessing*. In this, his final epic painting of the series, Murillo collected the virtuous, admirable figures away from the ignominious Laban and firmly anchored them with the two tents and large trees. Murillo segregated Laban and his heretical forces to the painting's opposite, right side, where the land drops precariously away. The viewer, who surely was to enjoy this canvas from a forty-five-degree angle similar to that he assumed for *The Blessing*, would presumably enlist spiritually with the virtuous women and children approaching Rachel's tent. Standing in the patron's home admiring Murillo's powerful evocations of Old Testament scripture, this seven-

teenth-century viewer would reaffirm his Catholic faith, the faith of
Seville, and that of all of Spain. For in Murillo's final composition,
Jesus Christ as Jacob, the Catholic church as Rachel, and the viewer, a
member of that church, achieve a complete rout of the forces of evil, a
victory of faith over heresy.

Epilogue
The Eclipse of a City

urillo's *The Life of Jacob* expresses a theory that triumph is possible with God's blessing. Murillo's lucky subject, Jacob, who excels both spiritually and materially did so because God favored him. In the seventeenth century and for Murillo's anguished compatriots, this illustrated concept explained Spain's mounting economic and political reversals. It proved that Spain's spiralling decline was the direct result of divine rejection from displeasure. This attitude of self-reproach was particularly exaggerated in Seville, the empire's prosperous showcase in the sixteenth century, which suffered grievous natural and economic disasters in the seventeenth century. Murillo's distraught fellow citizens interpreted these multiple calamities as God's angry retribution for their accumulated sins. Their resolve to achieve temporal relief through penance recalls the prodigal's spiritual resolution and explains the unparalleled success of the Jesuit missions in Andalusia in the late seventeenth century.

The notion that temporal afflictions are divine castigation for human offenses was current in Murillo's lifetime. At the Spanish court, Philip IV rued the individual transgressions that were costing him his empire, and in Seville, a disconsolate populace shouldered the blame for its city's multiple catastrophes. The anonymous chronicler who documented Seville's fatal epidemic of 1649 explained the plague as God's just punishment and instrument to convert the city's many obdurate sinners.[1] When the disease reappeared along the Andalusian coastline some years later, Seville hearkened to the words of the fanatical Jesuit

proselytizer Tirso González de Santalla (1624–1705), who declared that Seville would be spared God's vengeance if it eradicated the *comedias*, or secular plays, that vehemently offended Him. With the support of Seville's archbishop, Ambrosio Spínola, and the influential *hermano mayor* of the Brotherhood of Charity, Miguel Mañara, Tirso had his way, and Seville officially banned the *comedias* in 1679.[2]

It was during the decade 1669–1679 that Tirso's influence peaked in Seville. The Jesuit missionary, famous for his conversions in Spain, Italy, and Africa, first appeared in Seville in February of 1669, intent on persuading the wealthy port city's many reputed sinners to repent. Tirso's conspicuous methods, which featured public acts of contrition with physical mortification by the participants, were particularly effective in Seville, whose collective "piety and tenderness exceeded that of other Spanish cities." An eyewitness to Tirso's mission of 1669 estimated that eight thousand Sevillians heard his impassioned exhortations in the city's torchlit streets. Tirso's fiery declamations were joined by the cries of the remorseful and the persistent beat of their cruel discipline of face-slapping.[3]

In the days following the sermons, Tirso and his Jesuit assistants heard the individual confessions that were the fruits of the missions. Thousands of repentant Sevillians reviled their former vanities to embrace a chaster, more spiritual life. Among the sinners received by the fathers were proud aristocrats, common prostitutes, and a youthful character not unlike the biblical prodigal. Tirso recalled how, during the second Sevillian mission in 1672,

> a young man who had not confessed himself in ten years because he lived in sin heard the public act of contrition. With the first exhortation his soul was filled with such horror and dread of the divine judgment that he begged to be confessed. . . . Thereafter he attended all the sermons, and one night, deliberating over what was said regarding the soul that is in mortal sin, he fainted to the floor. He prepared his confession and with very great tears embraced all that his confessor ordered, including prayer, penitence, and fleeing the occasion to sin.[4]

This and other individual conversions recorded by Tirso's assistants

document the grass-roots religionism that flourished in the deteriorating city in the late seventeenth century.

But pious demonstrations could not salvage Seville, nor could they return it to its former prosperity. By 1670 the exodus of wealthy traders and bankers had expanded to include the Marquis of Villamanrique and other members of the elite nobility. Manuel Luis de Guzmán y Zúñiga, who had avidly supported the Jesuit missions and carried the standard in Tirso's procession of 1669, abandoned the floundering city in 1670 for the surer promise of prosperity of the court in Madrid.[5]

His exit was timely. The plague, which reappeared with alarming vigor in Seville in 1676, was followed in 1677 by torrential rains, which caused heavy crop losses. An ensuing famine was aggravated by droughts in the two subsequent years and by a disastrous earthquake in 1680. And as if these natural calamities were not sufficient castigation for the humbled city, the crown dealt a final, crushing blow when it officially designated Cadiz the exclusive port for the New World trade in 1680. Murillo, whose memorable narrative cycles *The Parable of the Prodigal Son* and *The Life of Jacob* were painted in the decade 1660–1670 of Spain's spiralling decline, died in Cadiz in 1682. His passing marked the end of Seville's Golden Age of painting and coincided with the final eclipse of that once-great Andalusian city.

Notes

Introduction

1. Murillo's *The Parable of the Prodigal Son* and *The Life of Jacob* are catalogued by Diego Angulo Iñiguez, *Murillo*, 2:25–34, cat. nos. 18–23 and 28–32, respectively.

2. Murillo's two series are dated by Angulo Iñiguez, *Murillo*, 2:25 and 29. The date, 1660–1670, for *The Parable of the Prodigal Son* is supported by Neil MacLaren, *An Exhibition of Spanish Paintings*, 13, and Wolfgang Stechow, "Laban Searching for His Stolen Household Gods in Rachel's Tent," 375, although August Liebmann Mayer, *Murillo*, 109–15, and Juan Antonio Gaya Nuño, *La pintura española fuera de España*, 250–51, preferred a broader date, 1660–1680. While Angulo Iñiguez, *Murillo*, 2:29, dates *The Life of Jacob* circa 1660, previous scholarship usually placed this series's execution between 1665 and 1670. See Martin Soria and George Kubler, *Art and Architecture in Spain and Portugal and Their American Dominions 1500–1800*, plate 146; Stechow, "Laban Searching," 367; and William B. Jordan, *The Meadows Museum*, 45. Because Angulo Iñiguez's more specific date of 1660 depends upon an unprovable, albeit widely accepted, theory, that *The Life of Jacob* is identical with canvases displayed in 1665 upon the facade of the Villamanrique palace, (see Fernando de la Torre y Farfán, *Fiestas que celebró la iglesia parroquial de Santa María la Blanca*, 14), it seems prudent for the present to provide a broader span of years for this series's execution. Murillo's four large lunettes for Seville's Church of Santa María la Blanca were completed by 1665, his paintings for Seville's Capuchin Monastery were executed between 1665 and 1668, and eight canvases commissioned by Miguel Mañara for the decoration of Seville's Church of the Brotherhood of Charity were painted between 1667 and 1672. See Angulo Iñiguez, *Murillo*, 2:41–45, 59–76, 77–92. For a detailed discussion of the latter commission, see Jonathan Brown, *Images and Ideas in Seventeenth-Century Spanish Painting*, 128–46.

3. Antonio Palomino de Castro y Velasco, in his treatise on art, *El museo*

pictórico y escala óptica, 1154, defined *historia* as "pintura que consta de algún caso histórico." Although Palomino, 650, explained historical episodes as events in recorded history, the Bible, and mythology, in inventories *historia* is a term most often applied to art works illustrating Old Testament scripture.

4. María Jesús Sanz and María Teresa Dabrío, "Inventarios artísticos sevillanos del siglo 18," 89–148, 102–6, and 130–34.

5. For the allegorical significance of Castillo's *The Life of Joseph,* see Mindy N. Taggard, "Narrative Meaning in Antonio del Castillo's *The Life of Joseph,*" *Gazette des Beaux-Arts* 116 (October 1990): 116–28. Gaspar Murillo's paintings are listed in the inventory of his possessions, published by Santiago Montoto de Sedas, "Nuevos documentos de Bartolomé Esteban Murillo," *Archivo Hispalense* 5 (1945): 319–57.

6. Palomino, *El museo,* 1082–83.

7. Murillo's six paintings *The Parable of the Prodigal Son* are first documented in the early nineteenth century. About 1850 they passed from the collection of the Marquis of Narros in Zaraúz (Spain) to that of the ennobled Spanish industrialist, the Marquis of Salamanca. The English Earl of Dudley purchased five of the canvases in 1867 and obtained the sixth, *The Return of the Prodigal Son,* through a trade with Pope Pius IX, who received the canvas in 1856 as a gift from Spain's Queen, Isabel II. Sir Alfred Beit acquired all six paintings in 1896. The series was presented to The National Gallery of Ireland by the Alfred Beit Foundation in 1987. Murillo's four small, preparatory oil sketches, *The Prodigal Son Receiving his Portion, The Departure of the Prodigal Son, The Prodigal Son Feasting,* and *The Repentance of the Prodigal Son,* are catalogued by Alfonso E. Pérez Sánchez, *Museo del Prado: Catálogo de las pinturas,* 455–56, cat. nos. 997–1000, and Angulo Iñiguez, *Murillo,* 2:25–27.

8. The five paintings that constitute *The Life of Jacob* were first recorded in 1787 in the Madrid palace of the Marquis of Santiago, by Richard Cumberland, *Anecdotes of Eminent Painters in Spain during the 16th and 17th Centuries,* 2:124. When the cycle was sold in 1808, *The Blessing of Jacob* and *The Dream of the Ladder* were acquired by the Czar of Russia; *The Laying of the Peeled Rods* was bought by the English Count of Northwick; and *Laban Searching for his Stolen Household Gods* was purchased by the Duke of Westminster. The unaccounted for *The Meeting of Jacob and Rachel* disappeared in 1817 following the Alexis Delahante sale in London. See Angulo Iñiguez, *Murillo,* 2:31–34. *The Laying of the Peeled Rods* entered the collection of the Meadows Museum in Dallas, Texas, in 1967, and *Laban Searching for his Stolen Household Gods* was acquired by the Cleveland Museum of Art in 1965.

9. *The Triumph of St. Hermengild* is studied by Alfonso E. Pérez Sánchez, *Carreño, Rizi, Herrera y la pintura madrileña de su tiempo, [1650–1700],* 267, cat.

no. 100. Claudio Coello's *The Triumph of St. Augustine* and *St. Catherine of Alexandria Dominating the Emperor Maxentius* are catalogued by Edward J. Sullivan, *Baroque Painting in Madrid: The Contribution of Claudio Coello, with a Catalogue Raisonné of His Works*, 106, cat. no. P7, and 108, cat. no. P9, respectively.

10. Calderón's use of allegory in his scripts is the subject of Alexander A. Parker's *The Allegorical Drama of Calderón*.

1. Precedents, Patron, and Allegory

1. *Canons and Decrees of the Council of Trent*, 216.

2. Francisco Pacheco, *El arte de la pintura*, 1:415.

3. Palomino, *El museo*, 575, 571–72.

4. Jonathan Brown, "Murillo, pintor de temas eróticos," identifies as prostitutes the women in Murillo's *Four Figures on a Step* (Kimbell Art Museum, Ft. Worth) and *Two Women at a Window* (National Gallery of Art, Washington, D.C.). Brown's interpretation, while undoubtedly correct, is difficult to prove given the absence in the paintings of customers, lewd gestures, and the paraphernalia usually associated with sex for sale in art, i.e., coins, beds, and musical instruments. For a discussion of the possible meanings, innocent and profane, of Murillo's *Two Women at a Window*, see Angulo Iñiguez, *Murillo*, 1:452–55.

5. Antonio Domínguez Ortiz, *Autos de la inquisición de Sevilla (siglo 17)*, 29, 77. Foreigners accounted for a hefty 27½ percent of Seville's population from 1660–1670.

6. Murillo's portraits of van Belle (1670; National Gallery of Art, Dublin) and Omazur (ca. 1660; Museo del Prado, Madrid) are illustrated by Angulo Iñiguez, *Murillo*, 2: plates 462 and 464. The inventory of Omazur's art collection is published by Duncan Kinkead, "The Picture Collection of Don Nicolás Omazur."

7. Santiago Montoto de Sedas, *Bartolomé Esteban Murillo, estudio biográfico-crítico*, 107, 94.

8. This theory was developed in conversation with a Spanish lawyer, José Antonio Cano, in 1985.

9. Although Montoto, *Murillo*, 107, blamed the disorganization of Seville's Archivo de Protocolos for his inability to locate the contract, it seems more likely the document was removed from the archive early on by persons unknown. This author's search for the contract proved fruitless, and the notary cited by Montoto's colleague, Jurado, as responsible for the document, is not included in the archive's present index.

10. Jesús María Granero, *Don Miguel Mañara*, 182–84, details the prob-

lems created for Spain's economy and society by the *mayorazgo* system of entailing estates. A solution to the overabundance of *mayorazgos* was proposed in 1600 by the Spanish reformer Christóbal Pérez de Herrera in a pamphlet, *A la Católica Real Magestad del Rey Don Felipe III nuestro Señor: cerca de . . . como parece podrían remediarse algúnos peccados, excessos, y desordenes, en los tratos, bastimientos, y otras cosas de que esta villa de Madrid al presente tiene falta.* Pérez de Herrera advised Philip III to prohibit the entailing of small estates valued under two thousand ducats.

11. Granero, 3-18, 562. Mañara and *don Juan* were associated as early as the nineteenth century by French writers Prosper Mérimée and Alexandre Dumas, who combined the literary character, *don Juan,* with the historic figure, Mañara, to create a third character, *don Juan de Mañara. Don Juan de Mañara* is the hero of Mérimée's *Les âmes du purgatoire* (1834) and Dumas's play, *Don Juan de Mañara ou la chute d'un ange* (1836).

12. Grace Hardendorff Burr, *Hispanic Furniture, from the Fifteenth through the Eighteenth Century,* 26-27.

13. José Manuel Cruz Valdovinos, "Piezas de platería en la pintura de Murillo," 72-74. Cruz Valdovinos's fig. 7 reproduces pattern 13 of the Sevillian silversmith's manual. Ewers like that represented in *The Prodigal Son Feasting* were out of style in Spain by 1620, but their appearance in three more paintings by Murillo, *The Marriage Feast at Cana* (fig. 15), *Moses Sweetening the Waters of Mara,* and *St. Elizabeth of Hungary Caring for the Sick,* (latter two, Church of la Caridad, Seville), suggests that in Seville their popularity continued into the last quarter of the seventeenth century.

14. Antonio de Pereda's (1611-1678) authorship of *The Dream of the Knight* is accepted by Diego Angulo Iñiguez and Alfonso E. Pérez Sánchez, *Historia de la pintura española; pintura madrileña del segundo tercio del siglo 17* (Madrid: Instituto Diego Velázquez, 1983) 227-28, but it is questioned by William B. Jordan, *Spanish Still Life in the Golden Age,* 218. Murillo's *Portrait of don Antonio de Hurtado de Salcedo* is illustrated by Angulo Iñiguez, *Murillo,* 3: plate 461.

15. José María Asensio, "El Compás de Sevilla," and Dr. Thebussem, "Mozas del partido y corredores de oreja," in *Segunda ración de artículos,* 361-97. Philip IV's law criminalizing prostitution is published in *Capítulos de Reformación, que su Magestad se sirve de mandar guardar por esta ley, para el govierno del Reyno,* iten. 23. The number of gaming houses in Seville in the seventeenth century is estimated by Porras, "Memorial del licenciado Porras de la Cámara al Arzobispo de Sevilla sobre el mal gobierno y corrupción de costumbres en aquella ciudad," *Revista de archivos, bibliotecas y museos* 4 (1900): 552.

16. *Recopilación de las leyes destos Reynos . . . que se ha mandado imprimir . . .*

por la Magestad Católica del Rey don Felipe Quarto el Grande nuestro Señor, lib. 7, tit. 12, ley 1, iten. 13.

17. Richard Ford, *A Hand-book for Travellers in Spain,* 3:1122.

18. The anonymous sixteenth-century play *Aucto del hijo pródigo* is published by Léo Rouanet, ed., *Colección de autos, farsas y coloquios del siglo 16,* 2:294–313.

19. Lope de Vega's *El hijo pródigo* is one of four one-act religious plays introduced by him into his romantic adventure novel, *El peregrino en su patria* (1604). Lope's *La prueba de los amigos* was not published until the nineteenth century, by José Sancho Rayón, ed., *Colección de libros españoles raros o curiosos: Comedias inéditas de Frey Lope de Vega Carpio* (Madrid, 1873): 237–359.

20. José de Valdivielso's *El hijo pródigo* is among fourteen of his religious plays published under the title, *Doze actos sacramentales y dos comedias divinas por el maestro Joseph de Valdivielso* (1622).

21. Tirso de Molina's *Tanto es lo de más como lo de menos* was published in *Doze comedias nuevas del maestro Tirso de Molina: Primera parte* (Seville, 1627). An earlier printing of the *Primera parte* may have been banned by the censors. See Alan K. G. Patterson, "Tirso de Molina: Two Bibliographical Studies," and chapter 2, note 10.

22. Luis de Miranda, *Comedia pródiga,* n.p.

23. José de Valdivielso, *El hijo pródigo,* 201, 207.

2. Creation: Wayward Souls and Positive Counterexamples

1. Saint Thomas Aquinas, ed., *St. Luke,* in *Catena aurea. Commentary on the Four Gospels, Collected out of the Works of the Fathers by St. Thomas Aquinas,* 530–33.

2. Ibid., 530.

3. The argument over free will arose from the church's inability to reconcile man's total dependence on the grace of God with his independent actions. The Dominicans accepted Luis de Molina's explanation, published in his *Concordia liberi arbitrii cum gratiae donis* (Lisbon, 1588), that God foresees the future act of man prior to determining to give him the grace that will bring about that free action, but the Jesuits rejected this theory for its implication that God is somehow dependent on His creatures. Eighty-five debates were held on the issue in Rome between 1602 and 1606, with the controversy laid to rest by Pope Paul V, who withheld judgment and allowed both interpretations to exist. See "Free Will and Grace," *New Catholic Encyclopedia,* 1967.

4. The Italian-born theorist at the Spanish court, Vicente Carducho (ca.

1576–1638), advised Spanish artists in his *Diálogos de la pintura*, 348, to paint "God the Father in the guise of a venerable old man . . . because there is no other more proper or efficaceous way to indicate, in our understanding, his eternity." Murillo follows Carducho's advice in his paintings, *Holy Family* (ca. 1640; Nationalmuseum, Stockholm) and *Virgin and Child with Saints* (ca. 1660–1665; Musée du Louvre, Paris).

5. Lope de Vega, *El hijo pródigo*, in *Biblioteca de autores españoles* 157:59–80, 64.

6. Herbert A. Kenyon, "Color Symbolism in Early Spanish Ballads," 328–29.

7. S. Griswold Morley, "Color Symbolism in Tirso de Molina," 77–78.

8. Bernard Dorival, "Callot, modèle de Murillo," 95–96.

9. Valdivielso, *El hijo pródigo*, 194–95.

10. Although Tirso criticizes Lazarus throughout the script for his imprudent charity, in the concluding scene Clemente advises the prodigal to avoid the glutton's, Nineucio's, extreme, as well as his own, and choose Lazarus's middle path. It seems likely, as argued by Jaime Asensio, "Sobre *Tanto es lo de más como lo de menos* de Tirso de Molina," 23, that Clemente's speech was retouched by Tirso at the insistence of his censors, his criticism of the charitable Lázaro meeting with the church's disfavor. See chapter 1, note 21.

11. Lope de Vega, *La prueba de los amigos*, 81.

12. Tirso de Molina, *Tanto es lo de más como lo de menos*, 366. Morley, 80–81. Because *encarnado* also signifies flesh color, Lope implies that the unconcerned prodigal will be naked when he departs the greedy courtesans.

13. Lope, *El hijo pródigo*, 68.

14. Tirso, *Tanto es lo de más*, 353; Valdivielso, *El hijo pródigo*, 183.

15. Valdivielso, *El hijo pródigo*, 185.

16. Lope, *El hijo pródigo*, 68, 64.

17. Juan de la Cerda, *Vida política de todos los estados de mugeres*, 244.

18. "Memorias de diferentes cosas sucedidas en esta muy noble y muy leal ciudad de Sevilla. Copiáronse en Sevilla año de 1696," n.p.

19. Diego Calleja, *Talentos logrados en el buen uso de los cinco sentidos*, 312–14.

20. According to Henryk Ziomek, ed., *La prueba*, 20–23, Leonarda and Dorotea are modeled after the two types of women in Lope's life. The virtuous Leonarda is a composite of Lope's two wives, Isabel de Urbina y Alderete and Juana de Guardo, who represented for the playwright the virtue of moral responsibility, and Dorotea is inspired by his two mistresses, Elena Osorio and Micaela Luján, who signified for Lope the pitfalls of love without marriage.

21. Another variation on the theme of the election between vice and virtue is José Antolinez's (1635–1675) mid-seventeenth-century canvas, *The*

Christian Soul between Vice and Virtue (Museo de Bellas Artes, Murcia). The Madrid painter, Antolinez, represents the soul of man as a nude infant who wisely chooses the gifts of virtue, including Christ's crown of thorns and nails, over the jewels and riches of vice.

22. Aquinas, *St. Luke*, 531.

3. The Fall of the Prodigal Son

1. Aquinas, *St. Luke*, 530, 540.
2. The definition of gluttony is given by Saint Thomas Aquinas, *Summa Theologica*, 74.
3. Saint John Chrysostom, *Homilies on the Gospel of Matthew*, 80.
4. Aquinas, *Summa*, 78.
5. Saint Gregory the Great, *The Book of Pastoral Rule and Selected Epistles*, 43; Aquinas, *Summa*, 76.
6. Pérez de Herrera's manifesto is appended to his book, *Proverbios morales, y consejos christianos*. The reformer first proposed his culinary limit in 1600, in *A la Católica Real Magestad*, 36–37. This missive directed to Philip III was aimed at curbing the excesses of Madrid's nobles so as to persuade the monarch not to transfer his court to Valladolid.
7. Francisco Martínez Montíño, *Arte de cocina, pastelería, vizcochería, y conservería*, 9–10.
8. Juan Francisco de Villava, *Empresas espirituales y morales*, 18.
9. Sebastián de Covarrubias y Orozco, *Emblemas morales*, 253.
10. Martínez Montíño, *Arte de cocina*, 232.
11. Miguel de Baeza, *Los quatro libros del arte de la confitería*, 77–80.
12. Antonio de Alvarado, *Arte de bien vivir y guía de los cielos*, 371–72.
13. Francisco de Miranda y Paz, *El desengañado*, 175–76.
14. Alvarado, *Arte de bien vivir*, 377.
15. Ibid.
16. Ibid., 378.
17. Miranda y Paz, *El desengañado*, 186.
18. Ibid., 179.
19. Pedro Calderón de la Barca, *Los encantos de la culpa, Autos Sacramentales*, 406–21, 417. *Los encantos de la culpa* was composed ca. 1640–1645.
20. Miranda y Paz, *El desengañado*, 175.
21. Juan de Borja, *Empresas morales*, 63.
22. Lope, *El hijo pródigo*, 71.
23. Valdivielso, *El hijo pródigo*, 188.
24. Lope, *La prueba*, 69, 77; Lope, *El hijo pródigo*, 71.

25. Calderón, *Los encantos*, 409-11.
26. Lope, *El hijo pródigo*, 70–71.

4. *Desengaño*, Repentance, and Absolution

1. Dorival, "Callot," 96.
2. Alvarado, *Arte de bien vivir*, 233.
3. Otto Vaenius, *Theatro moral de la vida humana en cien emblemas*, 12.
4. The Latin inscription on the banderole is translated by Edward J. Sullivan and Nina A. Mallory, *Painting in Spain 1650–1700*, 27.
5. Lope, *El hijo pródigo*, 75–76.
6. Ibid., 75.
7. Valdivielso, *El hijo pródigo*, 197–98.
8. Lope, *La prueba*, 65. Lope introduced a character comparable to Celestina, Fabia, into his dramatic script of ca. 1615–1626, *El caballero de olmedo*, and another, Gerarda, into his novel of 1632, *La dorotea*.
9. Aquinas, *St. Luke*, 529–31.
10. Angulo Iñiguez, *Murillo*, 2:213, cat. no. 238, catalogued *The Prodigal Amid the Swine* to Murillo with reservations. Angulo, who knew the painting only through a photograph, illustrates it in *Murillo*, 3: plates 325 and 326. For the influence of Dürer's print on Spanish artists, see chapter 4, note 15.
11. Dorival, "Callot," 96.
12. *Canons and Decrees*, 91, 93, 98–99.
13. Calleja, *Talentos*, 39–40.
14. Aquinas, *St. Luke*, 532.
15. As noted by Otto Kurz, *Bolognese Drawings of the 17 & 18 Centuries in the Collection of Her Majesty the Queen at Windsor Castle*, 96, Dürer's print is the ultimate source for Callot's *Repentance of the Prodigal*. Dürer's print was praised for its picturesque buildings evoking German villages by the sixteenth-century Italian biographer, Giorgio Vasari, *Lives of the Most Eminent Painters Sculptors and Architects*, 10 vols. (London: Philip Lee Warner, 1912–1914) 6:92. The popularity of Dürer's prints with Spanish painters is attested to by the contents of Domingo Guerra Coronel's studio, inventoried in Madrid in 1651. This inventory published by the Marquis of Saltillo, "Un pintor desconocido del siglo 17: Domingo Guerra Coronel," 46, lists 110 prints by Dürer and Lucas van Leyden, as well as a bound edition of Dürer's Passion Series.
16. Andrés Ferrer de Valdecebro, *Afectos pentitentes de una alma convertida con motivos grandes de bolverse a Dios*, 30.
17. Villava, *Empresas*, 50.
18. Brown, *Images and Ideas*, 126–46.

19. Murillo's source for this penetrating look exchanged between father and son probably was an etching by the Italian printmaker, Pietro Testa (1612–1650). See Angulo Iñiguez, *Murillo*, 2:25. Testa's print of a series of four is catalogued by Elizabeth Cropper, *Pietro Testa, 1612–1650: Prints & drawings* (Philadelphia Museum of Art, 1988) 211–16, cat. no. 98, who dates it ca. 1645. Testa's popular print was copied by two unidentified seventeenth-century Spanish painters (Church of San Andrés and Museo Provincial, both Valencia) and the Spanish draughtsman Juan Conchillos (1641–1711; Hispanic Society, New York). See Alfonso E. Pérez Sánchez, "Sobre un dibujo atribuido a Conchillos."

20. Alonso de Vascones, *Destierro de ignorancias, y aviso de penitentes,* 122.

21. Lorenzo Ortiz de Bujedo, *Ver, oír, oler, gustar, tocar,* 297.

22. Aquinas, *St. Luke,* 539–40.

23. Ferrer de Valdecebro, *Afectos,* 67–69, 71–75.

24. Valdivielso, *El hijo pródigo,* 207, 205.

25. Melchior Prieto, *Psalmodia eucharística,* 195.

5. Visual Sources, Patron, and Allegory

1. Cumberland, *Anecdotes,* 101–2, 124–25.

2. Stechow, "Laban Searching," 374–75. Stechow, who first entertained pious fraud as the unifying theme of *The Life of Jacob,* rejected this for its failure to account for the cycle's romantic third episode, *The Meeting of Jacob and Rachel.*

3. Kempeneer's weavings, created for the Hapsburg Emperor Charles V, are based upon designs by the monarch's court artist, Bernard van Orley (ca. 1488–1541). The tapestries are identified as one of Murillo's sources by Stechow, "Laban Searching," 372, and discussed in full by Marthe Crick-Kuntziger, *La tenture de l'histoire de Jacob d'après Bernard van Orley.*

4. In 1623 the tapestries decorated the Royal Chapel in Madrid for the baptism of Philip IV's daughter, Margarita. Crick-Kuntziger, *La tenture,* 29. Although Murillo's eighteenth-century biographer, Antonio Palomino, *El museo,* 1031, credited the Sevillian with an early visit to Madrid during which Philip IV's court portraitist, Diego de Velázquez, introduced him to the art works in the Alcázar and El Escorial palaces, his only documented journey to Madrid occurred in the spring of 1658. See Angulo Iñiguez, *Murillo,* 1:45–48.

5. Jusepe Martínez, *Discursos praticables del nobilísimo arte de la pintura,* 237–38. Orrente's extant paintings of the story of Jacob have been catalogued into their original series by Diego Angulo Iñiguez and Alfonso E. Pérez

Sánchez, *Historia de la pintura española; escuela toledana de la primera mitad del siglo 17*, 261–68.

6. Palomino, *El museo*, 865.

7. Unfortunately, a photograph of Orrente's *The Blessing of Jacob* was unavailable for reproduction in this book. The painting is illustrated by Roberto Longhi and August L. Mayer, *The Old Spanish Masters from the Contini-Bonacossi Collection*, plate 45, and Angulo Iñiguez and Pérez Sánchez, *Historia de la pintura española; escuela toledana*, plate 165.

8. Palomino, *El museo*, 1036.

9. Cumberland, *Anecdotes*, 124–25.

10. Angulo Iñiguez, *Murillo*, 2:29; and Torre y Farfán, *Fiestas*, 14. After the death of his childless cousin, Brianda de Zúñiga, in 1662, the Marquis of Villamanrique was also Marquis of Ayamonte. See *Memorial de el pleyto que sigue don Manuel de Zúñiga y Guzmán, Duque de Bexar . . . con doña Luisa Josepha, Marquesa de Villamanrique . . . sobre la propiedad del estado de Ayamonte*.

11. Torre y Farfán, *Fiestas*, 14.

12. Angulo Iñiguez, *Murillo*, 2:29.

13. Torre y Farfán, *Fiestas*, 14.

14. Although Rubens's tapestry cycle was created for a cloistered convent, the designs were familiar to Spanish artists, many of whom copied them, through the reproductive prints issued soon after the cycle's completion. See Alfonso E. Pérez Sánchez, "Rubens y la pintura barroca española."

15. Palomino interprets his painting of 1705 in *El museo*, 724–31.

16. Most of the plays in the codex are published by Rouanet, ed., *Colección de autos*. James Pyle Wickersham Crawford, *Spanish Drama before Lope de Vega*, 142, notes that in the codex the four plays dedicated to the story of Jacob make this patriarch second in popularity only to Abraham, whose biography is interpreted a total of five times. The dramatized events of Jacob's life are his flight to Haran, the struggle with the angel, the rape of his daughter Dinah, and the death of Jacob.

17. Lope's *El robo de Dina* was published in part 23 of *Comedias de Lope de Vega* (Madrid, 1638). S. Griswold Morley and Courtney Bruerton, *Cronología de las comedias de Lope de Vega* (Madrid: Editorial Gredos, 1968) 550, believe he wrote the script between 1615 and 1622. Calderón's *Primero y segundo Isaac* was published in 1677, in *Autos sacramentales, alegóricos e historiales, dedicados a Christo Señor nuestro sacramentado*. The play is included in Calderón, *Autos Sacramentales*, 801–20.

18. Alonso de Villegas Selvago, *Flos sanctorum. Segunda parte y historia gen-*

eral en que se escrive la vida de la Virgen . . . y de los santos antiguos, que fueron antes de la venida de nuestro Salvador al mundo, 168, 174.

19. Saint François de Sales, *Sermons,* 199.

20. The inventory of the Marquis's possessions, conducted in Madrid after his death on March 26, 1693, could establish this noble's sponsorship of *The Life of Jacob.* But this crucial document, which should be among the papers of the notary, Andrés de Caltañazor, in Madrid's Archivo Histórico de Protocolos, but is not, must for the present be presumed lost. Manuel de Guzmán's testament is where it should be, in Madrid's Archivo Histórico de Protocolos, Andrés de Caltañazor, 9889, fols. 424–25.

6. Jacob as a Figure for the Redeemer

1. In the seventeenth century, The Blessing of Jacob was illustrated by Dutch painters Govert Flinck (Rijksmuseum, Amsterdam) and Jan Victors (Musée du Louvre, Paris) and Italian artists Bernardo Strozzi (Pinacoteca, Pisa) and Antonio Zanchi (Museum of Fine Arts, Boston).

2. Orrente's painting is identified as Murillo's compositional source for *The Blessing of Jacob* by Alfonso E. Pérez Sánchez, "Introduction" to Eric Young's *Todas las pinturas de Murillo,* 10.

3. Saint Ambrose, "Jacob and the Happy Life," 150–52. Ambrose's interpretation of the blessing was adapted by sixteenth-century Spanish playwright Diego Sánchez de Badajoz (ca. 1479–1552) for his one-act script, *Farsa de Isaac,* in *Libros de Antaño,* ed. by Vicente Barrantes y Moreno, 2:88–103. Sánchez de Badajoz's humorous character, *Bato,* recalls Rebecca's difficult pregnancy when he says, "In the womb they (Jacob and Esau) battled with ardent envy, and all those who descended from them, who never loved each other well, are the Jews and the Gentiles" (90).

4. Ambrose, "Jacob," 150–52.

5. Juan de Mal Lara, *La philosophía vulgar,* 205.

6. Ambrose, "Jacob," 150–51, 149.

7. The dream of the ladder is paired with the feast of Job's children in a fifteenth-century *Biblia Pauperum* preserved in the Cathedral at Esztergom, Hungary. A facsimile of this precious block book was published in 1967 by Corvina Press. In a fourteenth-century Italian *Speculum Humanae Salvationis,* Jacob's dream is coupled with Christ's ascension, the return of the lost sheep to the fold, and the translation of Elijah. This Italian manuscript was reproduced by Oxford University Press in 1926.

8. The dream of the ladder is illustrated in canvases by seventeenth-century

Italian painters Domenico Fetti (Kunsthistorisches Museum, Vienna) and Cristofano Allori (Museum, Turin), numerous Dutch artists of the Rembrandt school, and the Spanish Baroque masters Ribera (Museo del Prado, Madrid), Orrente (private collection, Barcelona, and Kunsthistorisches Museum, Vienna), and Juan de Zamora (Archbishop's Palace, Seville).

9. Ambrose, "Jacob," 155–56.

10. Villegas, *Flos Sanctorum*, 167.

11. Prieto, *Psalmodia*, 199, 474. Prieto, 200, interpreted the divine pledge received by Jacob as evidence of God's favor toward the Christian people and the glorious destiny of the Catholic faith. He said, "To no other nation, except the faithful, did God reveal His secrets. . . . And in having, as the Church has within her doors her God, she becomes superior to all other fortresses of people who were, are, or ever will be, in the world. . . . In this the Christian people win and excel above all others."

12. Luis Vélez de Guevara, *Comedia famosa de la hermosura de Raquel*, 139; and Lope de Vega, *Obras son amores*, in *Biblioteca de autores españoles* 157:105–21, 109.

13. Lope, *Obras son amores*, 110.

14. Ambrose, "Jacob," 156–57.

15. Nagel's print is one in a set of seven, *The Acts of Charity*, designed by the Dutch artist Maerten van Heemskerck (1498–1574). Nagel's printed series is catalogued in *Dutch and Flemish Etchings, Engravings and Woodcuts, ca. 1450–1700*, edited by F. W. H. Hollstein, et al., 14:126.

16. Gustav Fredrick Waagen, *Treasures of Art in Great Britain*, 4 vols. (London, 1854) 3:204, was first to cite Momper's paintings as sources for the landscape of Murillo's *The Laying of the Peeled Rods*. Waagen's opinion is supported by Angulo Iñiguez, *Murillo*, 1:474–75, who notes that between 1627 and 1628 at least thirteen landscapes by Momper entered the Sevillian art market. Bril's paintings were well enough known in Seville for the theoretician and painter Francisco Pacheco to cite him as a master of the landscape discipline in his treatise of 1649. See Pacheco, *El arte*, 2:127. The resemblance of Murillo's landscape to Iriarte's Prado composition is noted by Stechow, "Laban Searching," 375, and Angulo Iñiguez, *Murillo*, 1:475.

17. Palomino, *El museo*, 1036.

18. Lope de Vega, *El pastor lobo y cabaña celestial*, in *Biblioteca de autores españoles* 157:321–37, 321, 334. The script is one of twelve *autos sacramentales* by Lope published posthumously, in *Fiestas del santísimo sacramento, repartidas en doze autos sacramentales, con sus loas y entremeses* (Madrid, 1644).

7. An Allegory of the Faith: Christ and the Church Victorious over Heresy

1. Herrera Barnuevo's paintings in the Chapel of Our Lady of Guadalupe are illustrated and discussed by Harold E. Wethey and Alice Sunderland Wethey, "Herrera Barnuevo and his Chapel in the Descalzas Reales."

2. Palomino, *El museo,* 706.

3. Ambrose, "Jacob," 160. Palomino, *El museo,* 706, also paralleled Rachel to the Church. Explaining her significance as he painted her in his fresco in San Juan del mercado, he said: "beautiful Rachel . . . represents the Catholic Church . . . divine Jacob contracted new nuptials with her, preferring her to her sister Leah in whom the ancient law was represented."

4. This sale catalogue contains the last recorded mention of *The Meeting of Jacob and Rachel.* See Angulo Iñiguez, *Murillo,* 2:32–33.

5. Antolinez's *Jacob and Rachel at the Well* is given to Murillo by Juan Antonio Gaya Nuño, *La obra pictórica completa de Murillo,* 105, cat. no. 209. Six small paintings of the story of Jacob by Antolinez are in Seville's cathedral. They are catalogued by Enrique Valdivieso, *Catálogo de las pinturas de la Catedral de Sevilla,* 66–67, cat. nos. 271–76.

6. Ambrose, "Jacob," 24; and Sales, *Sermons,* 199.

7. Lope de Vega's *auto sacramental, Del pan y del palo,* was published in *Fiestas del santíssimo sacramento* (Madrid, 1644). It is included in *Biblioteca de autores españoles* 157:225–39.

8. Calderón, *Primero y segundo Isaac,* 815.

9. In the seventeenth century, Laban searching for his stolen household gods was illustrated by Dutch painters Pieter Lastman (Musée de Boulogne) and Jan Bijlert (Museum Boymans-van Beuningen, Rotterdam), French artist Sébastien Bourdon (Musée du Louvre, Paris), and the Italian master, Giovanni Castiglione (Musée Albi).

10. Orrente's painting was identified as the journey of the family of Lot by Pedro de Madrazo, *Catálogo del Museo del Prado* (Madrid, 1872) cat. no. 493. The correct title was supplied by Angulo Iñiguez and Pérez Sánchez, *Historia de la pintura española,* 293, cat. no. 179.

11. In Cesare Ripa's popular emblem book, *Iconologia, overo descrittione di diverse imagini,* 64, Charity is represented as a buxom young woman nursing an infant and flanked by two small children.

12. Ambrose, "Jacob," 302.

13. Lope de Vega, *La siega,* in *Biblioteca de autores españoles* 157:297–312, 302.

14. Ambrose, "Jacob," 159–60.

15. Julián Gállego, *Visión y símbolos en la pintura española del siglo de oro*, 252–54, has shown that in Spanish, Renaissance, and Baroque painting there is one dress for Christians and another for pagans. While Christians are represented as Roman soldiers or according to styles current in an artist's lifetime, pagans usually appear in Moorish attire. This rule is illustrated by two paintings of the martyrdom of St. James, one by Juan Fernández de Navarrete "el Mudo" (1571; El Escorial) and the other by Francisco de Zurbarán (ca. 1636–41; Museo del Prado, Madrid). In both examples the pagan oppressors are represented wearing Moorish turbans, although St. James was executed at the order of Herod Agrippa, King of Judea.

16. Pedro Calderón de la Barca, *A Dios por razón de estado*, *Autos Sacramentales*, 850–69, 857. The date of 1649 is Alexander A. Parker's, "The Chronology of Calderón's *Autos Sacramentales* from 1647," 180–81.

17. Calderón's *La cura y la enfermedad*, written about 1657–1658, *La cena del Rey Baltasar*, composed in 1634, and *El gran mercado del mundo*, of about 1635, were published in 1717, in *Autos sacramentales, alegóricos e historiales del insigne poeta español*. All three plays are included in Calderón, *Autos Sacramentales*, 750–73, 155–77, and 225–42, respectively.

18. Lope, *La siega*, 309.

19. Juan de Horozco y Covarrubias, *Emblemas morales*, 127.

20. Lope de Vega, *Las aventuras del hombre*, in *Biblioteca de autores españoles* 157:269–86, 285.

8. The Patron's Triumph

1. Ambrose, "Jacob," 150, 155–57, 159, 160–61, 302.

2. Carducho, *Diálogos*, 329.

3. Palomino, *El museo*, 651.

4. The frescoes by Eugenio Caxés and Jerónimo de Cabrera are catalogued by Diego Angulo Iñiguez and Alfonso E. Pérez Sánchez, *Historia de la pintura española: escuela madrileña del primer tercio del siglo 17*, 258, cat. no. 216, and 84, cat. no. 12, respectively. Patricio Caxés's (d. 1622) choice of Joseph as a subject for the queen's gallery was criticized by Carducho, *Diálogos*, 331, and Palomino, *El museo*, 838, who deemed scenes of virtuous scriptural matrons more apropos for the decoration of a lady's chamber.

5. Enrique Valdivieso and J. M. Serrera, *Catálogo de las pinturas del Palacio Arzobispal de Sevilla*, 13–15.

6. Manuel's birth in Seville in 1627, recorded by an anonymous seventeenth-century chronicler, is in *Memorias de Sevilla*, 58.

7. Manuel's baptism is recorded in *Memorial de el pleyto*, 62–63. An anonymous biographer records the exploits of Antonio Sancho Dávila, third Marquis of Velada, in a manuscript, "Servicios de Antonio Dávila, tercer Marqués de Velada, desde que nació en 1590 hasta que salió de Génova en 1647." Ana Dávila was baptized on April 29, 1626, in Oran (Africa). See "Indice alfabético de los documentos que existen en el Archivo de el Excsm. Sr. don Vicente Osorio de Moscoso, Conde de Altamira y Marqués de Astorga y de Velada," leg. 43, no. 5. The record of Ana and Manuel's marriage, preserved in Madrid's Real Academia de la Historia, Colección Luis de Salazar y Castro, M-4, fol. 187, identifies Ana as lady-in-waiting to Philip IV's queen, Isabel. Ana Dávila died in Madrid on July 21, 1692. Her testament is preserved in Madrid's Archivo Histórico de Protocolos, Andrés de Caltañazor, 9888, fols. 109–18.

8. Melchor was baptized in Santa María la Blanca on October 18, 1651, with his grandmother, the Marquise of Villamanrique, serving as godmother. Antonio was baptized in the same church on October 29, 1653, with Ana's brother Fernando, who was a Canon of the Cathedral of Malaga, serving as godfather. *Memorial de el pleyto*, 274–75. Bernardino was baptized on June 2, 1668, R-16, fol. 139, Colección Luis de Salazar y Castro. Real Academia de la Historia, Madrid. Since Constanza married in 1668 and bore a child the following year, she must have been born between 1652 and 1654. See *Arboles genealógicos de las casas de Berwick, Alba y agregadas*, n.p. María Andrea, who married in 1683, may have been born sometime during the 1660s, M-4, fol. 188, Colección Luis de Salazar y Castro. Real Academia de la Historia, Madrid.

9. Melchor married Ana de la Cerda on December 8, 1677. She died childless three years later. Melchor's second marriage, to Mariana Fernández de Córdoba, sister of the Marquis of Priego, produced two children, Joaquín and Ana Nicolaisa. Ana Nicolaisa inherited Melchor's estates and titles at his death in 1710, *Indice alfabético*, leg. 43, no. 5, and leg. 14, no. 35. Constanza's marriage to Antonio de Toledo took place in Seville on June 10, 1668, *Arboles genealógicos*, n.p. María Andrea's wedding is recorded in M-4, fol. 188, Colección Luis de Salazar y Castro, Real Academia de la Historia, Madrid.

10. Francisco de Asís Ruiz de Arana y Osorio de Moscoso Dávila, *Noticias y documentos de algunos Dávila, señores y marqueses de Velada*, 314–15, publishes a letter sent by Antonio Pedro Dávila to Ana in 1673 regarding the progress of her son, Antonio, in Naples.

11. Alvaro Pérez Osorio, ninth Marquis of Astorga, died on November 20, 1659. The legitimacy of Antonio's claim to the succession was contested by the Count of Altamira in a suit that was settled in Antonio's favor in 1677,

Memorial ajustado del pleito que se litiga entre D. Gaspar de Moscoso Ossorio, Conde de Altamira . . . con Don Antonio Pedro Alvarez Ossorio, Marqués de San Román, sobre la tenuta, y posessión del . . . Marquesado de Astorga, y demás estados, y mayorazgos, que vacaron en 20 de Noviembre del año passado de 1659 por fin, y muerte de Don Alvaro Pérez Ossorio, nono Marqués de Astorga.

12. The Marquises of Astorga belonged to the most elite stratum of the Spanish nobility, *grandes de primera clase,* whereas the Marquises of Velada figured among the more numerous and less important *grandes de segunda clase.* Antonio Domínguez Ortiz, *La sociedad española en el siglo 17,* 215–16, 360–61.

13. Brianda de Zúñiga, Marquise of Ayamonte, received her title in 1652 after three years of litigation. Possibly she designated her heir at that time. A portion of her testament, which was opened after her death in 1662, is printed in *Memorial de el pleyto.*

14. The biography of Manuel's grandfather is told by Dr. Thebussem, "Condes de Niebla y Duques de Medina Sidonia," in *Tercera ración de artículos,* 164–91, and "El séptimo Duque de Medina Sidonia," in *Cuarta ración de artículos,* 41–47. Gaspar's biography is told by Pedro Armero Manjón, "El último Señor de Sanlúcar de Barrameda."

15. The conspiracy of Gaspar and his cousin and its outcome is detailed by Antonio Domínguez Ortiz, *La conspiración del Duque de Medina Sidonia y el Marqués de Ayamonte.* A useful English summary of the events is found in John H. Elliott, *The Count-Duke of Olivares: The Statesman in an Age of Decline* (New Haven: Yale University Press, 1986) 616–20.

16. On his deathbed, Manuel Alonso Pérez de Guzmán entrusted the care of his grandsons, Manuel and Francisco, to Gaspar, *Relación de las cosas más particulares sucedidas en España, Italia, Francia, Flandes, Alemania, y otras partes desde Febrero de 1636, hasta fin de abril de 1637,* 175. In 1640, when the widower, Gaspar, brought his second bride to Sanlúcar, Manuel and Francisco were living in the Medina-Sidonia palace. Alonso Chirino Bernardes, *Panegyrico Nupcial. Viage del Excelentíssimo Señor Don Gaspar Alonso Pérez de Guzmán el Bueno, Duque de Medina Sidonia, Conde de Niebla, Marqués de Cazaza . . . en las bodas con la Excelentíssima Señora doña Juana Fernández de Córdoba, hija del Excelentíssimo Señor Marqués de Priego, Duque de Feria,* 39.

17. Manuel entered the Brotherhood of the Holy Sacrament on July 27, 1660. See Angulo Iñiguez, *Murillo,* 1:336. He is one of eighteen members of the Brotherhood of Charity listed in the published rule of the order, *Regla de la muy humilde Hermandad de la Ospitalidad de la S. Caridad de Nuestro Señor Jesu Christo; sita en su casa, y Hospital del Señor San Jorge de la ciudad de Sevilla,* 195.

18. Luca Ramírez de Zúñiga, "Auto general de la fee que se hizo en la ciudad de Sevilla a 13 de abril del año de 1660." The larger number of victims that year was the result of the discovery of some fifty Portuguese Jews in Osuna, near Seville, in 1659.

19. Torre y Farfán, 165. Torre y Farfán, 169, credits Manuel's wife, Ana, and her ladies-in-waiting with crafting the statue's elegant vestments.

20. Bernardo López, *Descripción de las sumptuosas fiestas que obsequioso celebró el Real Convento de San Pablo de Sevilla, a la Beatificación de la insigne Patrona del Nuevo Reyno, y Bienaventurada Rosa de Santa María. En este año de 1668, n.p. Elias Reyero, Misiones del M.R.P. Tirso González de Santalla 1665–1686*, 195, publishes an eyewitness account of the Palm Sunday procession.

21. Paolo Giovio, *Diálogo de las empresas militares y amorosas*, 103. A similar boulder frames the figure of Joachim in Juan de Valdés Leal's *Annunciation to Joachim* (ca. 1656–1660; The Meadows Museum, Dallas). An emblem virtually identical to Giovio's appears published in Juan de Borja's *Empresas morales*, 34–35.

22. Juan de Solórzano Pereyra, *Década de los emblemas*, 3:355–56, 359.

23. Seventeenth-century Spanish collectors usually hung Old Testament paintings in the public areas of their homes. Catalogued in the Duke of Alcalá's Seville palace between 1620 and 1630 are two Old Testament scenes in the large salon, a copy of Orrente's Jacob in the dining room, and an "Adam and Eve" in the duke's office. See Jonathan Brown and Richard L. Kagan, "The Duke of Alcalá: His Collection and Its Evolution," 249–50; 3, nos. 6, 34, and 251; 5, no. 11; 7, nos. 4, 7. Fine-quality Old Testament paintings were often reserved for a patron's large salon. The 1700 inventory of the paintings in the Princess of Esquilache's Madrid palace lists three Old Testament scenes in the richly decorated large salon: *The Sacrifice of Isaac, Judith and Holofernes,* and *The History of Susanna.* See Mercedes Agulló y Cobo, *Noticias sobre pintores madrileños de los siglos 16 y 17*, 199–200. Whether the Marquis of Villamanrique's large salon in his Seville palace was ample enough to accommodate Murillo's paintings cannot be determined at the present time. Little more than the facade remains of this ruined edifice once described as magnificent by Félix González de León, *Noticia artística de todos los edificios públicos de esta muy noble ciudad de Sevilla*, 105. Since the palace is earmarked for restoration by the Junta of Andalusia, the salon's dimensions might be determined at a future date.

Epilogue: The Eclipse of a City

1. "Memorias," n.p.

2. Most of the literature engendered by the issue of the *comedias*'s morality

is gathered by Emilio Cotarelo y Mori, *Bibliografía de las controversias sobre la licitud del teatro en España* (Madrid: Est. de la *Revista de archivos, bibliotecas y museos*, 1904).

3. Reyero, *Misiones*, 196, 195.

4. Ibid., 325.

5. Palomino, *El museo*, 1036.

Bibliography

Agulló y Cobo, Mercedes. *Noticias sobre pintores madrileños de los siglos 16 y 17.* Granada: Universidad, 1978.

Alemán, Mateo. *Guzmán de Alfarache.* 7th ed. Zaragoza: Editorial Ebro, 1972.

Alvarado, Antonio de. *Arte de bien vivir y guía de los cielos.* Navarre, 1608.

Ambrose, Saint. "Jacob and the Happy Life." In *Seven Exegetical Works,* translated by Michael P. McHugh, 119–84. Washington: Catholic University of America Press, 1972.

Angulo Iñiguez, Diego. *Murillo.* 3 vols. Madrid: Espasa-Calpe, 1981.

———. *Pintura del siglo 17.* Vol. 15, *Ars Hispaniae.* Madrid: Editorial Plus-Ultra, 1971.

———, and Alfonso E. Pérez Sánchez. *Historia de la pintura española; escuela madrileña del primer tercio del siglo 17.* Madrid: Instituto Diego Velázquez, 1969.

———. *Historia de la pintura española; escuela toledana de la primera mitad del siglo 17.* Madrid: Instituto Diego Velázquez, 1972.

Arboles genealógicos de las casas de Berwick, Alba y agregadas, 2d ed. Madrid: Talleres Tipográficos Blass, 1948.

Armero Manjón, Pedro. "El último Señor de Sanlúcar de Barrameda." *Archivo Hispalense* 27 (1957): 201–7.

Asensio, Jaime. "Sobre *Tanto es lo de más como lo de menos* de Tirso de Molina." *Reflexión* 2 (1973): 21–37.

Asensio, José María. "El Compás de Sevilla." In *La Sevilla de Cervantes,* 37–43. Seville: Caja Rural Provincial, 1982.

Augustine, Saint. *Basic Writings of St. Augustine.* 2 vols. New York: Random House, 1948.

———. *Faith, Hope and Charity.* Translated by Louis A. Arand. London: The Newman Press, 1947.

"Auto de fee celebrado en Sevilla el año de 1660." 1660. MS. 718, fols. 415–16. Biblioteca Nacional, Madrid.

Ayala, Francisco Javier de. *Ideas políticas de Juan de Solórzano.* Seville: Escuela de Estudios Hispano-Americanos, 1946.

Baeza, Diego de. *Commentaria allegorica, et moralia de Christo figurato in Veteris Testamento.* Vol. 1. Valladolid, 1632.

Baeza, Miguel de. *Los quatro libros del arte de la confitería.* Alcalá de Henares, 1592.

Barrera y Leirado, Cayetano Alberto de la. *Catálogo bibliográfico y biográfico del teatro antiguo español desde sus origenes hasta mediados del siglo 18.* Madrid, 1860.

Barrionuevo, Jerónimo de. *Avisos de don Jerónimo de Barrionuevo (1654–1658).* Vols. 221, 222, *Biblioteca de autores españoles.* Madrid: Atlas, 1968.

Bartolomé Esteban Murillo. Madrid: Museo del Prado, 1982.

Bennassar, Bartolomé. *La España del siglo de oro.* Translated by Pablo Bordonava. Barcelona: Editorial Crítica, 1983.

Biblia Pauperum. Facsimile edition of the forty-leaf blockbook in the library of the Esztergom Cathedral. Budapest: Corvina, 1967.

Biblia Sacra. Basel, 1578.

Bleiberg, German, ed. *Diccionario de historia de España.* 3 vols. Madrid: Ediciones de la Revista de Occidente, 1968–1969.

Bloomfield, Morton Wilfred. *The Seven Deadly Sins.* East Lansing: Michigan State College Press, 1952.

Borja, Juan de. *Empresas morales.* 1581. Madrid: Fundación Universitaria Española, 1981.

Brown, Jonathan. *Images and Ideas in Seventeenth-Century Spanish Painting.* Princeton: Princeton University Press, 1978.

———. *Murillo and His Drawings.* Princeton: Princeton University Press, 1976.

———. "Murillo, pintor de temas eróticos." *Goya* nos. 169–71 (1982): 35–43.

Brown, Jonathan, and Richard L. Kagan. "The Duke of Alcalá: His Collection and Its Evolution." *Art Bulletin* 69 (1987): 231–55.

Bucher, Francois. *The Pamplona Bibles.* New Haven: Yale University Press, 1970.

Burke, Marcus B. *A Selection of Spanish Masterworks from the Meadows Museum.* Dallas: Meadows Museum, 1986.

Burr, Grace Hardendorff. *Hispanic Furniture, from the Fifteenth through the Eighteenth Century.* New York: Archive Press, 1964.

Cabrera de Córdoba, Luis. *Relaciones de las cosas sucedidas en la corte de España, desde 1599 hasta 1614.* Madrid, 1857.

Calderón de la Barca, Pedro. *Autos sacramentales.* Vol. 3, *Obras Completas.* Madrid: Aguilar, 1967.

Calleja, Diego. *Talentos logrados en el buen uso de los cinco sentidos.* Madrid, 1700.

Canons and Decrees of the Council of Trent. Translated by H. J. Schroeder. St. Louis: B. Herder, 1941.

Capítulos de Reformación, que su Magestad se sirve de mandar guardar por esta ley, para el govierno del Reyno. Madrid, 1623.

Carducho, Vicente. *Diálogos de la pintura.* 1633. Edited by Francisco Calbo Serraller. Madrid: Turner, 1979.

Carrillo, Martín. *Historia o elógios de las mugeres insignes de que trata la sagrada escritura en el viejo testamento.* Madrid, 1783.

Ceán Bermúdez, Juan Agustín. *Diccionario histórico de los más ilustres profesores de las bellas artes en España.* 6 vols. Madrid, 1800.

Cerda, Juan de la. *Vida política de todos los estados de mugeres.* Alcalá de Henares, 1599.

Chamberlain, Vernon A. "Symbolic Green: A Time-Honored Characterizing Device in Spanish Literature." *Hispania* 51 (1968): 29–37.

Chirino Bernardes, Alonso. *Panegyrico Nupcial. Viage del Excelentíssimo Señor Don Gaspar Alonso Pérez de Guzmán el Bueno, Duque de Medina Sidonia, Conde de Niebla, Marqués de Cazaza . . . en las bodas con la Excelentíssima Señora doña Juana Fernández de Córdoba, hija del Excelentíssimo Señor Marqués de Priego, Duque de Feria.* Cadiz, 1640.

Copiosa relación de lo sucedido en el tiempo que duró la epidemia en la grande y augustísima ciudad de Sevilla, año de 1649. Ecija, 1649.

Covarrubias y Orozco, Sebastián de. *Emblemas morales.* 1610. Madrid: Fundación Universitaria Española, 1978.

———. *Tesoro de la lengua castellana o española.* Madrid, 1611.

Crawford, James Pyle Wickersham. *Spanish Drama before Lope de Vega.* Philadelphia: University of Pennsylvania Press, 1967.

Crick-Kuntziger, Marthe. *La tenture de l'histoire de Jacob d'après Bernard van Orley.* Antwerp: L'académie royale d'archéologie de Belgique, 1954.

Cruz Valdovinos, José Manuel. "Piezas de platería en la pintura de Murillo." *Goya* nos. 169–71 (1982): 68–74.

Cumberland, Richard. *Anecdotes of Eminent Painters in Spain, during the Sixteenth and Seventeenth Centuries.* 2d ed. 2 vols. London, 1787.

Curtis, Charles B. *Velázquez and Murillo: A Descriptive and Historical Catalogue.* London, 1883.

Dietz, Donald Thaddeus. *The "Auto Sacramental" and the Parable in Spanish Golden Age Literature.* Chapel Hill: University of North Carolina Press, 1973.

Domínguez Ortiz, Antonio. *Autos de la inquisición de Sevilla (siglo 17).* Seville: Ayuntamiento, 1981.

―――. *La conspiración del Duque de Medina Sidonia y el Marqués de Ayamonte.* Seville: Imprenta Provincial, 1961.

―――. *Orto y ocaso de Sevilla.* 3d ed. Seville: Universidad, 1981.

―――. *La Sevilla del siglo 17.* Seville: Universidad, 1984.

―――. *La sociedad española en el siglo 17.* Madrid: Consejo Superior de Investigaciones Científicas, 1963.

Dorival, Bernard. "Callot, modèle de Murillo." *La Revue des Arts* 2 (1951): 94–101.

Dürer in America: His Graphic Work. Washington: National Gallery of Art, 1971.

Elliott, John H. *Imperial Spain 1469–1716.* New York: Penguin, 1981.

Felton, Craig, and William B. Jordan, eds. *Jusepe de Ribera.* Fort Worth: Kimbell Art Museum, 1982.

Fernández Bayton, Gloria. *Testamentaria del Rey Carlos II. Inventarios Reales 1.* Madrid: Museo del Prado, 1975.

Fernández de Moratín, Leandro. *Orígenes del teatro español.* Paris: Garnier, 1914.

Fernández Navarrete, Pedro. *Conservación de monarquias y discursos políticos sobre la gran consulta que el Consejo hizo al Señor Rey don Filipe Tercero.* Madrid, 1626.

Ferrer de Valdecebro, Andrés. *Afectos penitentes de una alma convertida con motivos grandes de bolverse a Dios.* Alcalá, 1675.

Fichter, William L. "Color Symbolism in Lope de Vega." *Romanic Review* 18 (1927): 220–31.

Ford, Richard. *A Hand-book for Travellers in Spain.* 1847. 2d ed. Vol. 3. Carbondale: Southern Illinois University Press, 1966.

François de Sales, Saint. *Sermons.* Vol 8, *Oeuvres de Saint François de Sales.* Annecy: J. Nierat, 1897.

Gállego, Julián. *Visión y símbolos en la pintura española del siglo de oro.* Madrid: Aguilar, 1972.

García Hidalgo, José. *Principios para estudiar el nobilísimo y real arte de la pintura.* 1693. Madrid: Instituto de España, 1965.

Garrigou-Lagrange, Reginald. *The Three Ages of the Interior Life.* Translated by Sister M. Timothea Doyle. 2 vols. St. Louis: B. Herder, 1947–1948.

Gaya Nuño, Juan Antonio. *La obra pictórica completa de Murillo.* Barcelona: Editorial Noguer, 1978.

―――. *La pintura española fuera de España.* Madrid: Espasa-Calpe, 1958.

Giovio, Paolo. *Diálogo de las empresas militares y amorosas.* Lyons, 1562.

González de León, Félix. *Noticia artística de todos los edificios públicos de esta muy noble ciudad de Sevilla*. 1844. Seville: Gráficas del Sur, 1973.

Granada Maldonado, Diego. *Libro del arte de cozina*. Madrid, 1599.

Granero, Jesús María. *Don Miguel Mañara*. Seville: Artes Gráficas Salesianas, 1963.

Gregory the Great, Saint. *The Book of Pastoral Rule and Selected Epistles*. Vol. 12, *Select Library of the Nicene and Post-Nicene Fathers of the Christian Church*, translated by James Barmby. Grand Rapids: W. B. Eerdmans, 1956.

Guzmán, Pedro de. *Bienes de el honesto trabajo, y daños de la ociosidad en ocho discursos*. Madrid, 1614.

Hollstein, F. W. H. *Dutch and Flemish Etchings, Engravings and Woodcuts, ca. 1450–1700*. Amsterdam: M. Hertzberger, 1949– .

———. *German Engravings, Etchings and Woodcuts, ca. 1400–1700*. Amsterdam: M. Hertzberger, 1954– .

Horozco y Covarrubias, Juan de. *Emblemas morales*. Segovia, 1589.

"Indice alfabético de los documentos que existen en el Archivo de el Excsm. Sr. Don Vicente Osorio de Moscoso, Conde de Altamira y Marqués de Astorga y de Velada." MS., n.d. Archivo del Instituto de Valencia de don Juan, Madrid.

The Illustrated Bartsch. New York: Abaris, 1978–1989.

John Chrysostom, Saint. *Homilies on the Gospel of Matthew. A Select Library of the Nicene and Post-Nicene Fathers of the Christian Church*. Vol. 10. Grand Rapids: W. B. Eerdmans, 1956.

Jordan, William B. *The Meadows Museum*. Dallas: Southern Methodist University, 1974.

———. *Spanish Still Life in the Golden Age*. Fort Worth: Kimbell Art Museum, 1985.

Justi, Carl. *Murillo*. Leipzig: E. A. Seemann, 1904.

Kamen, Henry. *Spain in the Later Seventeenth Century, 1665–1700*. New York: Longman, 1980.

Kennedy, Ruth L. "Studies for the Chronology of Tirso's Theatre." *Hispanic Review* 11 (1943): 42–46.

Kenyon, Herbert A. "Color Symbolism in Early Spanish Ballads." *Romanic Review* 6 (1915): 327–40.

Kinkead, Duncan. "The Picture Collection of Don Nicolás Omazur." *Burlington Magazine* 128 (1986): 135–44.

Kirschbaum, Engelbert, ed. *Lexikon der Christlichen Ikonographie*. Rom: Herder, 1972.

Knipping, John Baptist. *Iconography of the Counter Reformation in the Netherlands: Heaven on Earth*. 2 vols. Nieuwkoop: De Graaf, 1974.

Kurz., Otto. *Bolognese Drawings of the 17 & 18 Centuries in the Collection of Her Majesty the Queen at Windsor Castle.* London: Phaidon, 1955.

León, Luis de. *La perfecta casada.* Salamanca, 1583.

Lieure, Jules. *Jacques Callot.* 8 vols. New York: Collectors Editions, 1969.

Longhi, Roberto, and August L. Mayer. *The Old Spanish Masters from the Contini-Bonacossi Collection.* Rome, n.p., 1938.

Lope de Vega Carpio, Félix. *Obras de Lope de Vega. Biblioteca de autores españoles,* Vols. 157, 159. Madrid: Ediciones Atlas, 1963.

―――. *El Peregrino en su patria.* Seville, 1604.

―――. *La prueba de los amigos.* Edited by Henryk Ziomek. Athens: University of Georgia Press, 1973.

López., Bernardo. *Descripción de las sumptuosas fiestas que obsequioso celebró el Real Convento de San Pablo de Sevilla, a la Beatificación de la insigne Patrona del Nuevo Reyno, y Bienaventurada Rosa de Santa María. En este año de 1668.* Seville, 1668.

Luque Faxardo, Francisco de. *Fiel desengaño contra la ociosidad, y los juegos.* Madrid, 1603.

Lynch, John. *Spain under the Hapsburgs.* 2 vols. Oxford: B. Blackwell, 1964–1969.

MacLaren, Neil. *An Exhibition of Spanish Paintings.* London: Arts Council of Great Britain, 1947.

Mâle, Émile. *L'art religieux de la fin du 16 siècle, du 17 siècle et du 18 siècle; etude sur l'iconographie après le Concile de Trent.* 2d ed. Paris: A. Colin, 1951.

Mal Lara, Juan de. *La philosophía vulgar.* Seville, 1568.

Mallory, Nina Ayala. *Bartolomé Esteban Murillo.* Madrid: Alianza Editorial, 1983.

Mañara Vicentelo de Leca, Miguel. *Discurso de la verdad.* Seville, 1679.

Martínez., Jusepe. *Discursos practicables del nobilísimo arte de la pintura.* Barcelona: n.p., 1950.

Martínez Montíño, Francisco. *Arte de cocina, pastelería, vizcochería, y conservería.* Madrid, 1662.

Mayer, August Liebmann. *Historia de la pintura española.* Madrid: Espasa-Calpe, 1928.

―――. *Murillo.* Stuttgart and Berlin: Deutsche Verlags-Antalt, 1913.

Memorial ajustado del pleito que se litiga entre D. Gaspar de Moscoso Ossorio, Conde de Altamira . . . con Don Antonio Pedro Alvarez Ossorio, Marqués de San Román, sobre la tenuta, y possessión del . . . Marquesado de Astorga, y demás estados, y mayorazgos, que vacaron en 20 de Noviembre del año passado de 1659 por fin, y muerte de Don Alvaro Pérez Ossorio, nono Marqués de Astorga. 1660.

S-15, Colección Luis de Salazar y Castro. Real Academia de la Historia, Madrid.

Memorial de el pleyto que sigue don Manuel de Zúñiga y Guzmán, Duque de Bexar . . . con doña Luisa Josepha, Marquesa de Villamanrique . . . sobre la propiedad del estado de Ayamonte. 1666. T-14, 217–316, Colección Luis de Salazar y Castro. Real Academia de la Historia, Madrid.

"Memorial del licenciado Porras de la Cámara al Arzobispo de Sevilla sobre el mal gobierno y corrupción de costumbres en aquella ciudad." *Revista de archivos, bibliotecas y museos* 4 (1900): 550–54.

"Memorias de diferentes cosas sucedidas en esta muy noble y muy leal ciudad de Sevilla. Copiáronse en Sevilla año de 1696." 1696. MS. 84-7-21. Biblioteca Colombina, Seville.

Memorias de Sevilla. Edited by Francisco Morales Padrón. Cordoba: Monte de Piedad y Caja de Ahorros, 1981.

Mendo, Andrés. *Príncipe perfecto y ministros ajustados, documentos políticos y morales.* Lyons, 1661.

Miranda, Luis de. *Comedia pródiga.* 1554. Valencia: Amparo, 1953.

Miranda y Paz, Francisco de. *El desengañado.* Toledo, 1663.

Montoto de Sedas, Santiago. *Bartolomé Esteban Murillo, estudio biográfico-crítico.* Seville: Imprenta y Librería Sobrino de Izquierdo, 1923.

———. "Inventario de bienes de Bartolomé Esteban Murillo." *Archivo Hispalense* 5, nos. 12–14 (1945): 322–29.

———. "La biblioteca de Murillo." *Bibliografía Hispánica* 7 (1946): 464–79.

Morley, S. Griswold. "Color Symbolism in Tirso de Molina." *Romanic Review* 8 (1917): 77–81.

Nagy, Edward. *El pródigo y el pícaro.* Valladolid: Sever-Cuesta, 1974.

Ortiz de Bujedo, Lorenzo. *Ver, oír, oler, gustar, tocar.* Lyons, 1687.

Ortiz de Zúñiga, Diego. *Anales eclesiásticos y seculares de la muy noble y muy leal ciudad de Sevilla . . . desde 1246 hasta 1671.* Madrid, 1677.

Pacheco, Francisco. *El arte de la pintura.* 1649. Annotated by F. J. Sánchez Cantón. 2 vols. Madrid: Instituto de Valencia de don Juan, 1956.

Palomino de Castro y Velasco, Antonio. *El museo pictórico y escala óptica.* 1715-1724. 3 vols. Madrid: Aguilar, 1947.

Parker, Alexander A. *The Allegorical Drama of Calderón.* Oxford: Dolphin Book Co., 1943.

———. "The Chronology of Calderón's *Autos Sacramentales* from 1647." *Hispanic Review* 37 (1969): 164–88.

Patterson, Alan K. G. "Tirso de Molina: Two Bibliographical Studies." *Hispanic Review* 35 (1967): 43–68.

Pérez de Herrera, Christóbal. *A la Católica Real Magestad del Rey Don Felipe III nuestro Señor: cerca de* . . . *como parece podrían remediarse algunos peccados, excessos, y desordenes, en los tratos, bastimientos, y otras cosas, de que esta villa de Madrid al presente tiene falta.* Madrid, 1600.

―――. *Amparo de pobres.* Introduction by Michel Cavillac. Madrid: Espasa-Calpe, 1975.

―――. *Proverbios morales, y consejos christianos.* Madrid, 1618.

Pérez Sánchez, Alfonso E. *Carreño, Rizi, Herrera y la pintura madrileña de su tiempo [1650–1700].* Madrid: Museo del Prado, 1986.

―――. *Museo del Prado: Catálogo de las pinturas.* Madrid: Museo del Prado, 1985.

―――. *Pintura italiana del siglo 17 en España.* Madrid: Universidad, 1965.

―――. "Rubens y la pintura barroca española." *Goya* 140–41 (1977): 86–109.

―――. "Sobre un dibujo atribuido a Conchillos." *Archivo Español de Arte* 170 (1970): 233–34.

Pieter Bruegel d. 'A' als Zeichner. Berlin: Staatliche Museen Preussischer Kulturbesitz, 1975.

Pigler, A. *Barockthemen, eine Auswahl von Verzeichnissen zur Ikonographie des 17. und 18. Jahrhunderts.* 2 vols. Budapest: Verlag der Ungarischen Akademie der Wissenschaften, 1956.

Poorter, Nora de. *The Eucharist Series.* 2 vols. London: Harvey Miller, 1978.

Por el Marqués de Salinas, Don Bernardino Dávila y Ossorio, . . . *con el Marqués de Astorga, Don Antonio Pedro Dávila y Ossorio, su hermano* . . . *sobre la tenuta del estado de Velada.* Circa 1666. X–17, 1–31, Colección Luis de Salazar y Castro. Real Academia de la Historia, Madrid.

Pregón en que su Magestad manda que ninguna muger de qualquier estado, y calidad que sea, pueda traer, ni traiga guardainfante, o otro qualquier instrumento, o trage semejante, excepto las mugeres que con licencia de las justicias públicamente son malas de sus personas. Seville, 1639.

Prieto, Melchior. *Psalmodia eucharística.* Madrid, 1622.

Ramírez de Zúñiga, Luca. "Auto general de la fee que se hizo en la ciudad de Sevilla a 13 de abril del año de 1660." 1660. MS. 9–3495–4. Real Academia de la Historia, Madrid.

Réau, Louis. *Iconographie de l'art chrétien.* 2 vols. Paris: Presses universitaires de France, 1955–1959.

Recopilación de las leyes destos reynos, hecha por mandado dela Magestad Cathólica del Rey don Philippe Segundo nuestro Señor. 2 vols. Alcalá de Henares, 1598.

Recopilación de las leyes destos Reynos . . . *que se ha mandado imprimir* . . . *por la Magestad Católica del Rey don Felipe Quarto el Grande nuestro Señor.* 3 vols. Madrid, 1640.

Regla de la muy humilde Hermandad de la Ospitalidad de la S. Caridad de Nuestro Señor Jesu Christo; sita en su casa, y Hospital del Señor San Jorge de la ciudad de Sevilla. Seville, 1675.

Relación de las cosas más particulares sucedidas en España, Italia, Francia, Flandes, Alemania, y otras partes desde Febrero de 1636, hasta fin de Abril de 1637. Madrid, 1637.

Reyero, Elías. *Misiones del M.R.P. Tirso González de Santalla 1665–1686.* Santiago de Compostela: Editorial Compostelana, 1913.

Ripa, Cesare. *Iconologia, overo descrittione di diverse imagini.* Rome, 1603.

Rouanet, Léo, ed. *Colección de autos, farsas y coloquios del siglo 16.* 4 vols. Barcelona: L'Avenc, 1901.

Ruiz de Arana y Osorio de Moscoso Dávila, Marquis of Velada, Francisco de Asís. *Noticias y documentos de algunos Dávila, señores y marqueses de Velada.* Madrid: Sucesores de Rivadeneyra, 1923.

Saltillo, Marquis of. "Un pintor desconocido del siglo 17: Domingo Guerra Coronel." *Arte Español* (1944): 43–48.

Sánchez Arjona, José. *Anales del teatro en Sevilla desde Lope de Rueda hasta fines del siglo 17.* Seville, 1898.

———. *El teatro en Sevilla en los siglos 16 y 17.* Seville, 1887.

Sánchez de Badajoz, Diego. *Farsa de Isaac.* In vol. 2, *Libros de Antaño,* edited by Vicente Barrantes y Moreno, 88–103. Madrid, 1886.

Sanz, María Jesús, and María Teresa Dabrío. "Inventarios artísticos sevillanos del siglo 18." *Archivo Hispalense* 57, no. 176 (1974): 89–148.

Sebastián, Santiago. *Contrarreforma y barroco.* Madrid: Alianza, 1981.

Selig, Karl Ludwig. "Concerning Solórzano Pereyra's *Emblemata regiopolitica* and Andrés Mendo's *Príncipe perfecto.*" *Modern Language Notes* 71 (1956): 283–87.

"Servicios de Antonio Dávila, tercer Marqués de Velada, desde que nació en 1590 hasta que salió de Génova en 1647." 1647. MSS. I–27, fols. 264–74; M–73, fols. 37–46, Colección Luis de Salazar y Castro. Real Academia de la Historia, Madrid.

Shergold, N. D., and J. Varey. *A History of the Spanish Stage from Medieval Times until the End of the Seventeenth Century.* Oxford: Clarendon Press, 1967.

Simón Díaz, José. *Bibliografía de la literatura hispánica.* 11 vols. Madrid: Consejo Superior de Investigaciones Científicas, 1960–1977.

Solórzano Pereyra, Juan de. *Década de los emblemas.* 10 vols. Translated by Lorenzo Matheu y Sanz. Valencia, 1658–1660.

———. *Emblemata centum, regio politica.* Madrid, 1653.

Soria, Martin, and George Kubler. *Art and Architecture in Spain and Portugal and Their American Dominions 1500–1800.* Baltimore: Penguin Books, 1959.

Soto, Hernando de. *Emblemas moralizadas*. Madrid, 1599.

Speculum Humanae Salvationis, Being a Reproduction of an Italian Manuscript of the Fourteenth Century. Oxford: Oxford University Press, 1926.

Stechow, Wolfgang. "Laban Searching for His Stolen Household Gods in Rachel's Tent." *Cleveland Museum of Art Bulletin* 53 (1966): 367–77.

"Sucesos del año 1624." 1624. MS. 2355. Biblioteca Nacional, Madrid.

Sullivan, Edward J. *Baroque Painting in Madrid: The Contribution of Claudio Coello with a Catalogue Raisonné of His Works*. Columbia: University of Missouri Press, 1986.

———, and Nina A. Mallory. *Painting in Spain 1650-1700*. Princeton: Princeton University Press, 1982.

Taggard, Mindy Nancarrow. "A Source for the Interpretation of Murillo's *The Parable of the Prodigal Son:* The Golden-Age Stage." *La Revue d'Art Canadienne* 14 (1987): 90–95+.

———. "Juan Sánchez Cotán and the Depiction of Food in Seventeenth-Century Spanish Still-life Painting." *Pantheon* 48 (1990): 76–80.

Thebussem, Dr. [Mariano Pardo de Figueroa]. "Cosas y casas de hidalgos." In *Un triste capeo*, 150–76. Madrid: 1892.

———. *Cuarta ración de artículos*. Madrid: Rivadeneyra, 1902.

———. *Quinta (y última) ración de artículos*. Madrid: Rivadeneyra, 1907.

———. *Segunda ración de artículos*. Madrid, 1894.

———. *Tercera ración de artículos*. Madrid, 1898.

Thomas Aquinas, Saint, ed. *St. Luke*. In *Catena aurea. Commentary on the Four Gospels, Collected out of the Works of the Fathers by St. Thomas Aquinas*, 3:529–47. London: J. Parker, 1874.

———. *Summa Theologica*. Translated by Fathers of the English Dominican Province. Vol. 13. London: R. and T. Washbourne, 1932.

Tirso de Molina. [Fray Gabriel Téllez]. *El burlador de Sevilla y convidado de piedra*. New York: Scribner's Sons, 1969.

———. *Tanto es lo de más como lo de menos. Obras de Tirso de Molina*. In *Biblioteca de autores españoles*, 238:343–98. Madrid: Ediciones Atlas, 1970.

Torre y Farfán, Fernando de la. *Fiestas que celebró la iglesia parrochial de Santa María la Blanca*. Seville, 1666.

Valbuena Prat, Angel. *Historia de la literatura española*. 8th ed. 4 vols. Barcelona: G. Gili, 1968.

Valdivieso, Enrique. *Catálogo de las pinturas de la Catedral de Sevilla*. Seville: author, 1978.

———, and J. M. Serrera. *Catálogo de las pinturas del Palacio Arzobispal de Sevilla*. Seville: n.p., 1979.

———. *El Hospital de la Caridad de Sevilla*. Seville: n.p., 1980.

Valdivielso, José de. *Doze actos sacramentales y dos comedias divinas por el maestro Joseph de Valdivielso.* Toledo, 1622.

———. *El hijo pródigo.* In *Piezas maestras del teatro teológico español,* edited by Nicolás G. Ruiz, 1:182–211. Madrid: Editorial Católica, 1946.

Vaenius, Otto. *Theatro moral de la vida humana en cien emblemas.* Antwerp, 1701.

Vascones, Alonso de. *Destierro de ignorancias, y aviso de penitentes.* Seville, 1619.

Vegas, Damián de. *Comedia llamada Jacobina o bendición de Isaac.* In *Biblioteca de autores españoles,* 35:509–24. Madrid: Librería y Casa Editorial Hernando, 1925.

Vélez de Guevara, Luis. *Comedia famosa de la hermosura de Raquel.* In *Flor de las comedias de España de diferentes autores. Quinta parte,* 133–89. Barcelona, 1616.

Villava, Juan Francisco de. *Empresas espirituales y morales.* Baeza, 1613.

Villegas Selvago, Alonso de. *Flos sanctorum. Segunda parte y historia general en que se escrive la vida de la Virgen . . . y de los santos antiguos, que fueron antes de la venida de nuestro Salvador al mundo.* Toledo, 1609.

Von Boehn, Max. *La moda, historia del traje en Europa desde los origenes del Cristianismo hasta nuestros días.* Vol. 3. Barcelona: Salvat, 1928.

Wardropper, Bruce. *Introducción al teatro religioso del siglo de oro: Evolución del auto sacramental, 1500–1648.* Madrid: Revista de Occidente, 1953.

Wethey, Harold E., and Alice Sunderland Wethey. "Herrera Barnuevo and His Chapel in the Descalzas Reales." *Art Bulletin* 48 (1966): 15–34.

Young, Eric. *Todas las pinturas de Murillo.* Barcelona: Editorial Noguer, 1982.

Index